THE UNOFFICIAL

# STRANGER THINGS COOKBOOK

FOR OSKAR "Ossi" BÖHM,

THE FATHER I NEVER HAD.

From now on, God above no longer
has the last word!

## THE UNOFFICIAL
# STRANGER
# THINGS
# COOKBOOK

TOM GRIMM

REEL
INK
PRESS

# CONTENTS

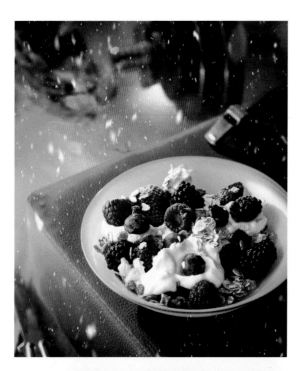

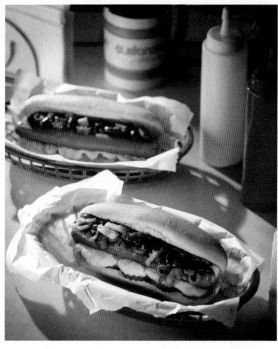

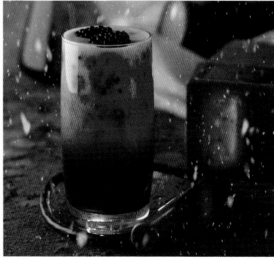

# STRANGER THOUGHTS

For someone like me who grew up reading Stephen King books, *Stranger Things* is a godsend—a gift I'd been hoping so long to receive that I didn't think it would ever happen.

Since I began my "reading career" in the mid-1980s (the older ones among you will remember), mainly with comics and illustrated magazines, Stephen King's *Firestarter* was the first "real" novel I ever read. I must have been twelve or thirteen at the time. And while that book can't be considered one of King's greatest achievements, the parallels to *Stranger Things*, the Duffer Brothers' terrific Netflix series, are unmistakable; after all, both are about a girl with special powers who escapes from a U.S. government research facility. The resemblance is quite striking.

Matt and Ross Duffer, the creators of *Stranger Things*, have also drawn from other early works by the "King of Horror," such as his masterpiece *It*. Apart from the fact that both stories are set in small-town America, everything revolves around a group of unpopular, nerdy, but good-hearted boys who are confronted with supernatural events and make the acquaintance of a mysterious girl who really gets their hormones going. But that's not all: The fearless Bob Newby, the superhero from the second season of *Stranger Things* and boyfriend of Joyce Byers, explained that he had grown up in Maine, where most of King's stories are set. This suggests that the creepy clown Bob encountered at the fair as a child that gave him nightmares for years might have been the killer clown Pennywise. Other scenes in *Stranger Things*, such as the different times the kids walk along the railroad tracks, seem to be taken straight from King's novella *The Body* or Rob Reiner's sensitive film adaptation *Stand by Me*. And when Billy Hargrove rams his head through the door to grab Max in season three, the only thing missing are Jack Nicholson's chilling words in *The Shining*, "Here's Johnny!"

In other words, *Stranger Things* captures the spirit of Stephen King's work a thousand times better than the many official King adaptations churned out for the uninitiated. And I am sincerely glad that this old guy is still around to experience it.

I grew up in a time when there were no cell phones, no Internet, and no Netflix. When I was young, we had only three TV channels, and you either watched what was on or rented a movie from a video store. Though it seems hard to believe now, you couldn't just watch what you felt like at the push of a button. *Stranger Things* takes me back to that time of my life in many ways, albeit with two not insignificant differences. First: There were no monsters in my hometown. And second: My meals were considerably more modest than the hearty, all-American fare you find in Hawkins, Indiana.

The latter was largely due to the fact that my mother was plainly the world's worst cook. For instance, she was firmly convinced that it was enough to simply throw Brussels sprouts, cauliflower, or asparagus into warm water and then serve them up twenty

minutes later in exactly the same way, without salt, without sauce, and with overly mushy, unseasoned potatoes that I wouldn't even feed to a pig. It would be a blessing for my brother and me to come home from school and find delicious ravioli from a can, nothing home-cooked. And whenever there was a special occasion to have takeout roast chicken, it was like Christmas and Easter had come at once. Far be it from me to speak ill of the dead, but the facts are the facts. And the truth is that my mother was no Mrs. Wheeler. She didn't spend the whole day in the kitchen to lovingly serve up hearty casseroles, delicious pies, and succulent roasts to her loved ones. What's more, there was nothing like Starcourt Mall in our area, where you could get burgers, fried chicken, or milkshakes in an ultra-trendy, food court for cheap. So I can justifiably say that I wasn't all that into the culinary arts when I was younger.

Although that changed later, it didn't make me a gourmet; nor did I become a second Paul Bocuse. But that suits me just fine as the food culture in *Stranger Things* is as firmly rooted in the 1980s as everything else in the series. It's no coincidence that most of the dishes in this book are so easy to make that even Dustin could pull it off, blindfolded, while hitting on Suzie (or trying to).

Cooking needn't be complicated, and these recipes show how true this is. There's no fine-dining on *Stranger Things*. The closest we get to highbrow cuisine in the series is Hopper waiting for Joyce at a fancy restaurant and then getting hopelessly drunk out of sheer frustration at being stood up by her. Here, you'll find plenty of snacks, fast-food favorites, sweet treats, ice cream, and lots of other unhealthy things to make you throw your diet out the window.

That's enough of that for now. I think it's quite clear what this is all about. It's about food. It's about the eighties. And, of course, it's about *Stranger Things*. And just like *Stranger Things*, this book is about one thing above all else: having fun. For me, at least, this project was an absolute dream, and not just because of my morbidly infantile imagination. To a large extent, it was because of all the great people who accompanied me throughout the journey and made this book possible in one way or another, whether they're actually aware of it or not. Detailed acknowledgements are at the end of this book.

Now, without further ado, comes the main attraction: more than sixty terrific recipes inspired by a fantastic series that will, hopefully, turn your (culinary) world upside down.

Sincerely,

Tom Grimm

# BREAKFAST

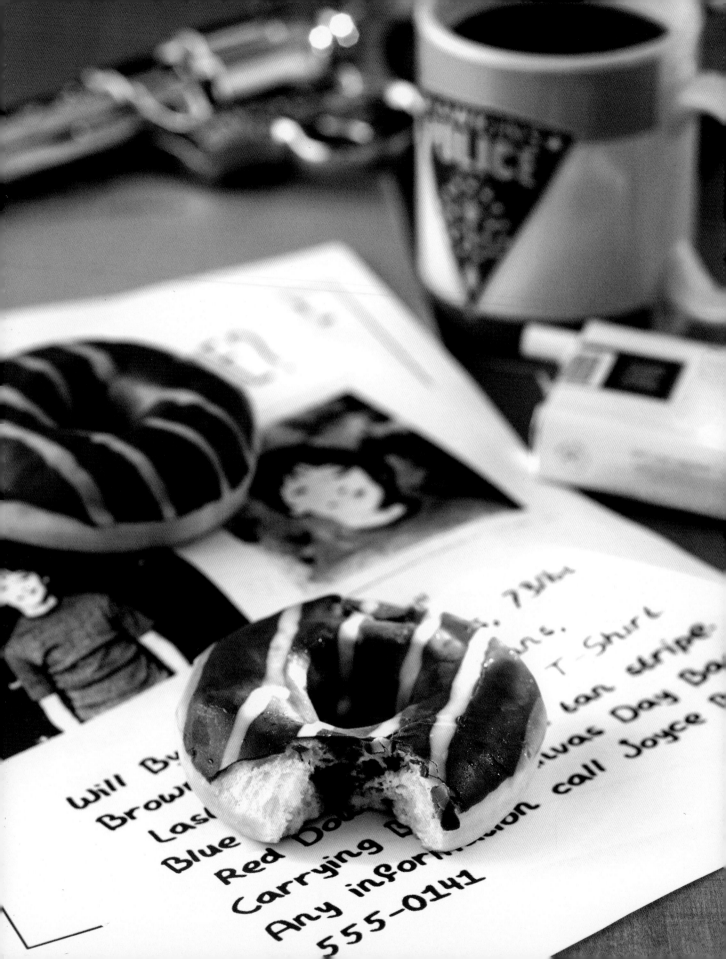

# *Hopper's*
# DOUGHNUTS

Very much in the style of Jim Hopper, these delicious doughnuts invite
you to sit back and contemplate over a cup of coffee, and not just at the
Hawkins police station.

## INGREDIENTS

MAKES 12–15

* 4 cups (1 lb 2 oz/ 500 g) pastry flour plus more for rolling out dough

* 2¼ tsp (7 g) instant yeast

* Scant 1 cup (7 fl oz / 200 ml) lukewarm milk

* ⅓ cup plus 1 tbsp (3 oz / 80 g) sugar

* 1 tsp vanilla extract

* ¾ stick / ⅓ cup plus 1 tbsp (3 oz/90 g) unsalted butter, softened

* 1 medium egg

* 1 medium egg yolk

* Salt

* 8½–12¾ cups (3½–5¼ pints/2–3 L) oil, for deep-frying

* 7 oz (200 g) dark chocolate couverture

* 1¾ oz (50 g) white chocolate couverture

Extras

* Doughnut cutter (3½ inches/9 cm in diameter; or drinking glass and shot glass)

## METHOD

In a large bowl, combine the flour with the yeast.

Mix in the milk, sugar, vanilla extract, butter, egg and egg yolk, and a large pinch of salt and then use a hand mixer fitted with a dough hook to knead everything to a soft, smooth dough, about 10 minutes. Cover the bowl with a clean kitchen towel and let the dough rise in a warm place until it doubles in size, about 1 hour.

Turn out the dough onto a lightly floured surface and roll out to a thickness of about ½ inch (1 cm). Cut out the doughnuts with a doughnut cutter or glasses. If you are using glasses, cut out disks with a drinking glass, and then use a shot glass to cut out a hole in the middle.

Lay the doughnuts, spaced apart, on a sheet of parchment paper, cover with a clean kitchen towel, and rest for 20 minutes.

In the meantime, heat the oil in a large pot to 340°F. Add 2–3 doughnuts at a time to the hot oil and fry on each side, about 2 minutes, until golden brown. Carefully remove from the oil with a slotted spoon and transfer to a plate lined with paper towels.

While the doughnuts are cooling a little, melt the dark chocolate couverture in a bowl over a bain-marie. Pour the melted chocolate into a shallow bowl, and glaze the doughnuts on one side by dunking them in the chocolate. Drain slightly, and then transfer the doughnuts, unglazed side down, to a plate lined with paper towels and let dry.

Melt the white chocolate in the same way and use a spoon to decorate the doughnuts evenly with white chocolate stripes. Let dry for a few minutes before serving.

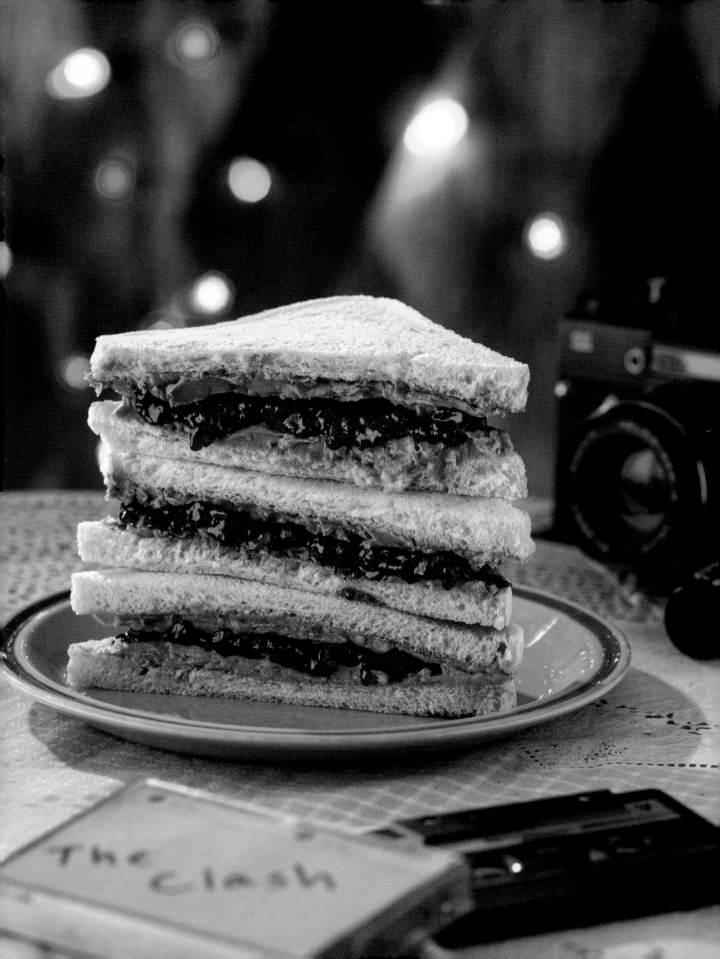

# Fried Peanut Butter and Jelly
# SANDWICHES

At first glance, the combination of peanut butter and jelly perfectly reflects the chaotic Byers household, yet the PB&J sandwich has been an integral part of the American breakfast table for more than fifty years. You'll appreciate this quick and easy classic in the morning, especially when every second counts.

## INGREDIENTS

SERVES 4

★ ⅔ cup (5¼ oz/150 g) peanut butter

★ 8 slices white bread

★ ¼ cup (8 oz/80 g) fruit jelly or preserve of your choice

★ 4 tbsp (2 oz/60 g) unsalted butter

## METHOD

Spread one side of four slices of bread with peanut butter and spread one side of the other four slices with jelly. Lay the peanut butter-covered slices, spread side down, over the jelly-covered slices. Spread the top of the sandwiches with plenty of butter.

Set a large skillet over medium heat.

Place sandwiches, butter side down, in the hot skillet and fry until golden brown, about 4 minutes. Then flip and fry the other side in the same way. Serve immediately.

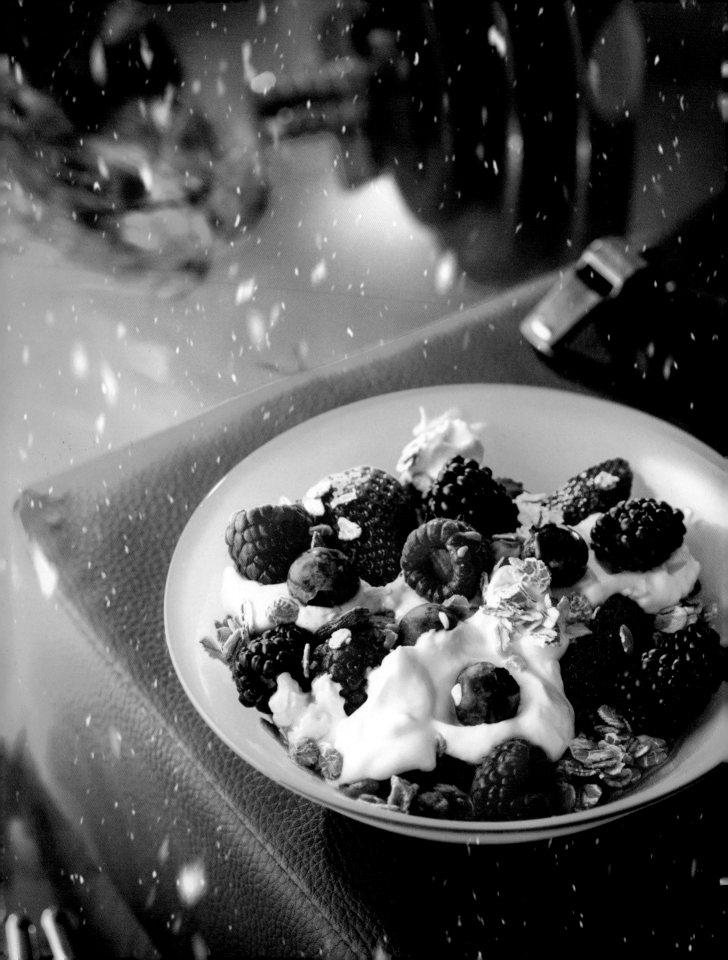

# Billy's
# POWER MUESLI

If there's something about Billy everybody agrees on, it's how fit he is. The women of Hawkins can't keep their eyes off him. Would you like to get in shape, too? Then you could use an extra boost of energy.

## INGREDIENTS

SERVES 4

* ★ ⅔ cup (3½ oz/100 g) each fresh strawberries, blueberries, raspberries, and blackberries

* ★ 1⅔ cups (5¼ oz/150 g) rolled oats

* ★ ⅔ cup (5¼ oz/150 g) vanilla yogurt or flavored yogurt of choice

* ★ 2 tbsp raisins

* ★ 2 tbsp lemon juice

* ★ Honey (as needed)

* ★ Ground cinnamon (as needed)

## METHOD

Wash, dry, and hull the strawberries. Halve or quarter them, depending on size. Wash and dry the blueberries and blackberries.

Roughly mix the oatmeal, yogurt, and raisins together in a bowl. Divide the mixture evenly into four breakfast bowls. Top with some of the fresh fruit and drizzle each with ½ tablespoon lemon juice.

Drizzle with honey and sprinkle with a little cinnamon. Enjoy immediately.

## STRANGER TIP

You can jazz up your muesli in many different ways. One way is by adding chopped hazelnuts or almonds. You can also easily make a batch of toasted muesli to keep in the pantry: Mix together 2 cups (7 oz/200 g) oats with 1½ cups (6½ oz/180 g) nuts and seeds of your choice and a little ground cinnamon. Heat 2 tablespoons sunflower oil and 1 tablespoon honey in a skillet and stir in the cereal mixture. Toast everything for 5 minutes. Add raisins if you like and toast the muesli for 5 more minutes. When cooled, the muesli will keep for several weeks in an airtight container.

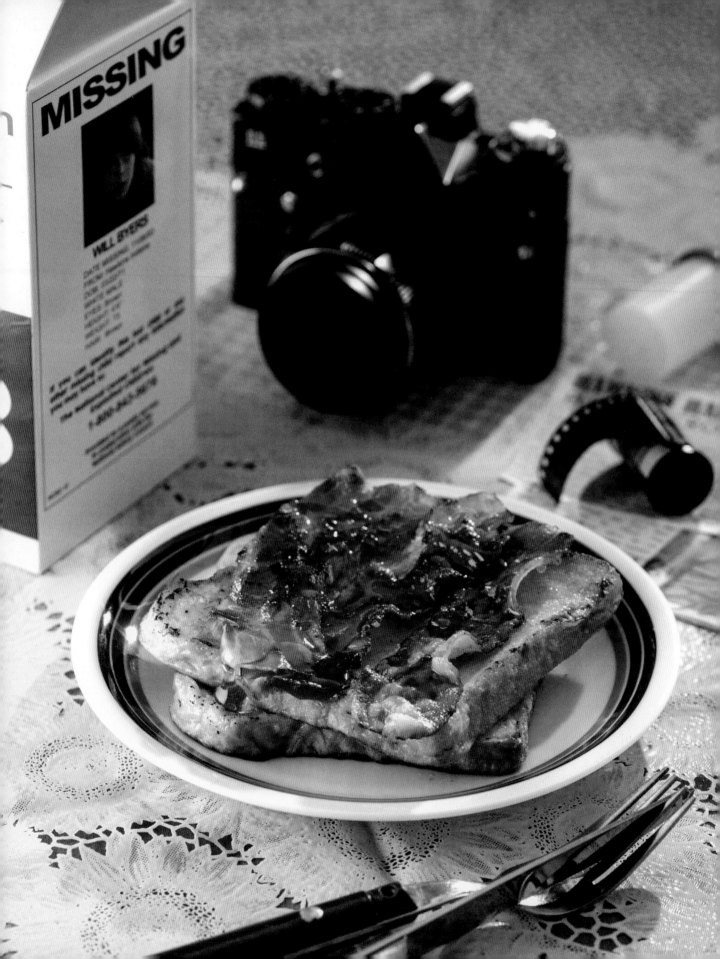

# FRENCH TOAST
## Jonathan Style

French toast is the perfect way to start the day. This version has just enough protein to keep Jonathan fueled all day, but you can also add any sweet or savory toppings to suit your appetite.

## INGREDIENTS

SERVES 4

★ 2 medium eggs

★ Scant ¼ cup
(1¾ fl oz/ 50 ml) milk

★ ½ tsp ground cinnamon

★ 1 tsp sugar

★ 1 tbsp unsalted butter

★ 4 slices toasting bread

★ 8¾ oz (250 g) bacon

★ Maple syrup
(as needed)

## METHOD

In a deep plate or bowl, whisk together the eggs, milk, cinnamon, and sugar.

Melt the butter in a large skillet over medium heat.

Dip the bread slices into the egg and milk mixture, drain slightly, and fry on both sides until golden brown, about 2–3 minutes per side. Transfer to a plate and cover loosely with aluminum foil to keep warm.

Wipe the skillet clean with paper towels. Then fry the bacon until crispy, about 3–4 minutes each side. Transfer to a plate lined with paper towels.

Arrange a slice of French toast on a plate, top with fried bacon, and drizzle with maple syrup to taste. Serve immediately.

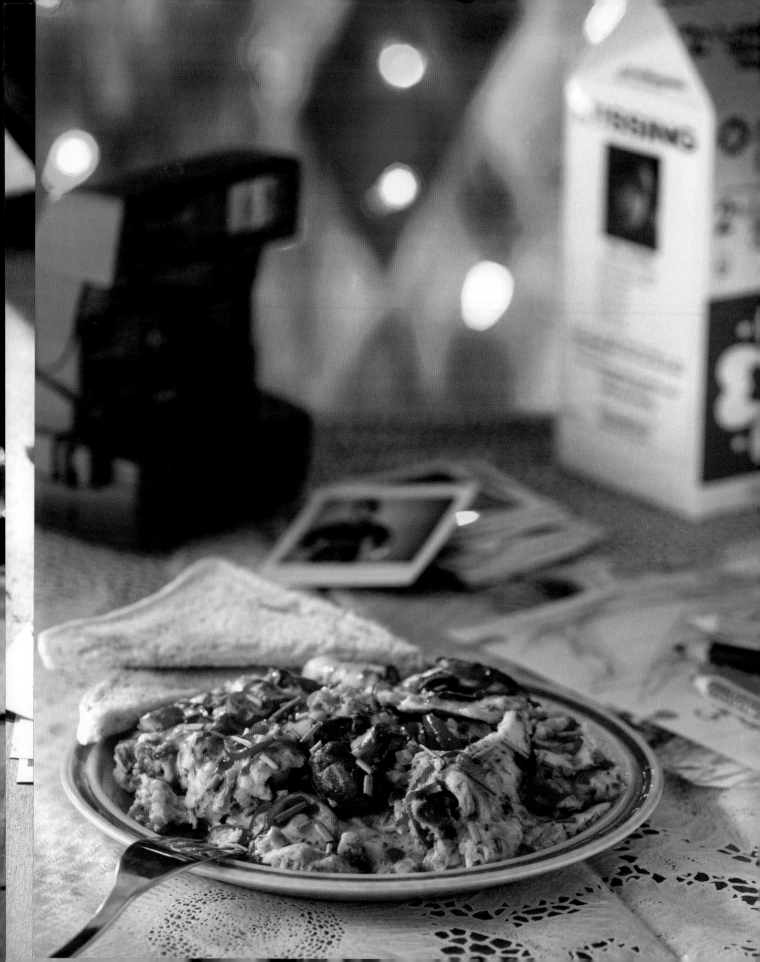

# *Spicy*
# SCRAMBLED EGGS

With countless variations, scrambled eggs make the perfect breakfast for hungry teens rushing off to Hawkins High. Try this variation for your next breakfast: spicy scrambled eggs with maple syrup and a glass of freshly squeezed orange juice.

## INGREDIENTS

SERVES 2–3

- ★ 5–6 Portobello mushrooms
- ★ 1 chile pepper
- ★ ¼–½ bunch chives
- ★ 4 medium eggs
- ★ ½ cup (4 fl oz/125 ml) light cream
- ★ Salt
- ★ Freshly ground black pepper
- ★ 2 tsp unsalted butter
- ★ 3½ oz (100 g) ham, roughly diced
- ★ Sriracha sauce (as needed)

## METHOD

Clean and slice the mushrooms. Seed and finely slice the chile. Wash, shake dry, and finely mince the chives. Set aside.

Crack the eggs into a high-sided bowl. Add the cream, liberally season with salt and pepper, and whisk until the mixture is still fairly thick, but creamy and consistent.

Melt the butter in a nonstick skillet over medium heat. Add the ham and sauté for 2–3 minutes to render the fat. Add the mushrooms, cover with a lid, and sauté for 2–3 more minutes. Add the chile, adjusting the amount to the amount of kick you want and then cover again and cook briefly. Take off the lid.

Add the egg mixture to the pan, mix well, and let set slowly. Carefully stir the mixture from time to time, pushing the spatula across the bottom of the pan to stop the eggs from burning and let them set evenly.

When at the desired consistency, divide the scrambled eggs into plates and sprinkle with chives. Drizzle with Sriracha sauce to taste and serve immediately. A word of warning: Have a big glass of milk ready!

# SNACKS & FAST FOOD

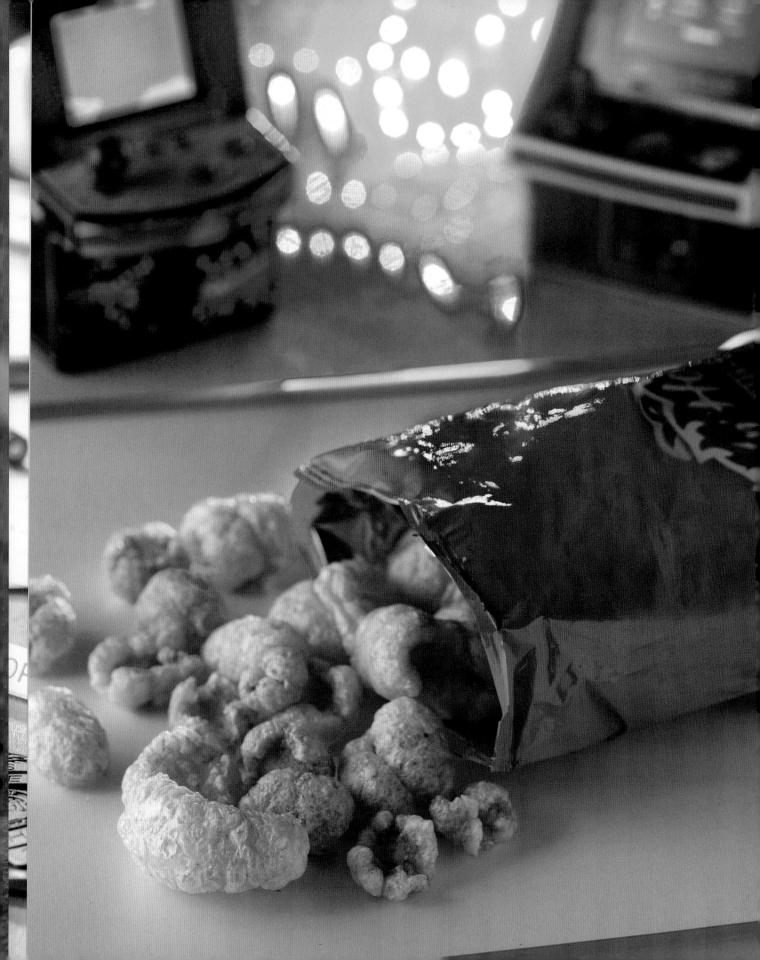

# *Original*
# PORK RINDS

Store-bought is so yesterday! Impress your guests at your next movie night with your own homemade snack.

## INGREDIENTS

MAKES 2.2 CUPS (500 G)

* 1 lb 2 oz (500 g) pork skin
* 2 cloves garlic
* Oil, for deep-frying
* Coarse sea salt
* Spices (optional; e.g., paprika, garlic, curry powder, etc.)

## METHOD

Fill a pot with water, add the garlic cloves, and bring to a boil over medium heat. Add the pork skin and simmer for 20 minutes. Take out the skin, drain in a colander or sieve, and pat dry with paper towels. Then cut into ¾-inch (2-cm) cubes (use kitchen scissors for the best results).

Heat oil in a large pot. If you dip a wooden spoon into the oil and small bubbles rise from the handle, it is hot enough to use. Next, place a batch of pork skin pieces in a skimmer and carefully immerse them in the oil. Deep-fry for 3–4 minutes until they puff up and turn golden brown all over. Make sure not to overcrowd the pot. Transfer to a plate lined with paper towels.

Serve the pork rinds in a large bowl seasoned with coarse sea salt. Add spices if desired. Eat them as soon as possible as they quickly become greasy. However, if this is the case, put them into an oven at 475°F for 5 minutes before serving.

## STRANGER TIP

The best way to source pork skin is to order it from your local butcher!

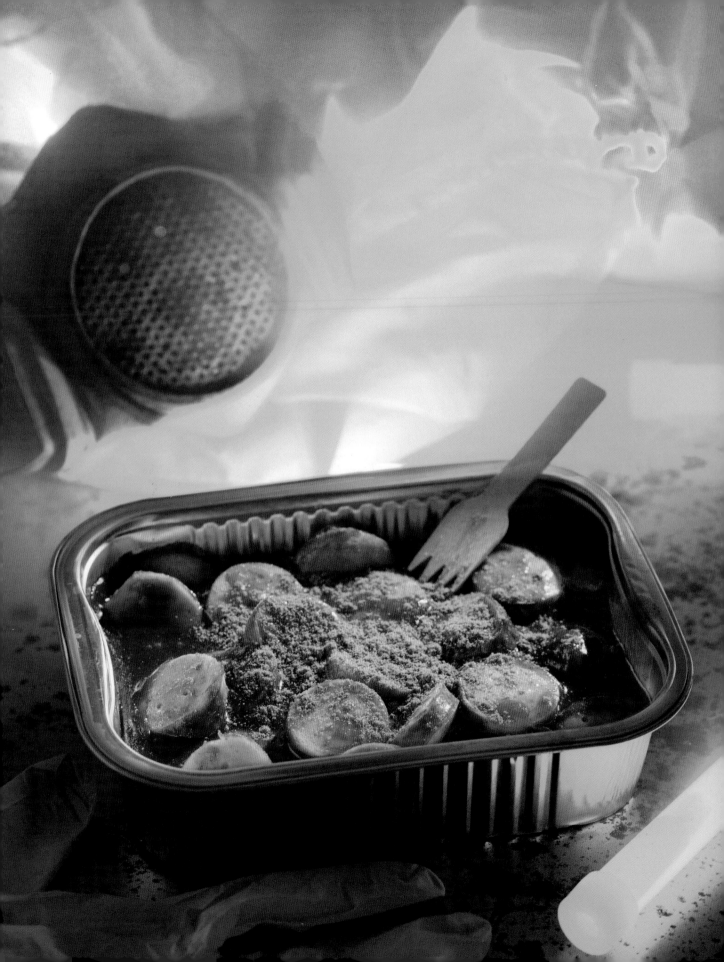

# Stranger
# CURRYWURST

Currywurst was long regarded as a prime example of German street food. Yet this iconic dish, with its sophisticated and versatile sauce, fits right in at any Hawkins dinner table. This dish can be adapted into a casserole, soup, or even added to a burger.

## INGREDIENTS

SERVES 2–3

For the sauce

* 2 tsp (½ fl oz/10 ml) olive oil
* ½ cup (4¼ oz/120 g) ketchup
* 2 tablespoons curry powder, plus more for seasoning
* ½ tsp Cayenne pepper
* ½ tsp vegetable bouillon powder
* 2 tbsp sugar
* Salt, pepper
* 1 dash apple cider vinegar

Extras

* 3 fine-ground bratwurst sausages
* 2 tbsp sunflower oil

## METHOD

In a small saucepan, mix the olive oil and ketchup with ¼ cup (2 fl oz/60 ml) of water. Bring to a boil over high heat, stirring regularly, and let simmer for 1 minute. Then add the curry powder, Cayenne pepper, vegetable bouillon, sugar, ½ teaspoon salt, a pinch of pepper, and the apple cider vinegar. Stir well to incorporate and let simmer for 3 minutes. Remove from the heat and let cool.

Prick the sausages with a knife at regular ¾–1¼-inch (2–3-cm) intervals to keep them from bursting when fried.

Pour the oil into a nonstick skillet over medium heat. Fry the sausages for about 6–8 minutes, turning regularly, until brown all over. Briefly transfer to a plate lined with paper towels, and then cut into bite-sized pieces. Divide the sausage pieces into serving bowls, pour over the sauce, and season with curry powder to taste.

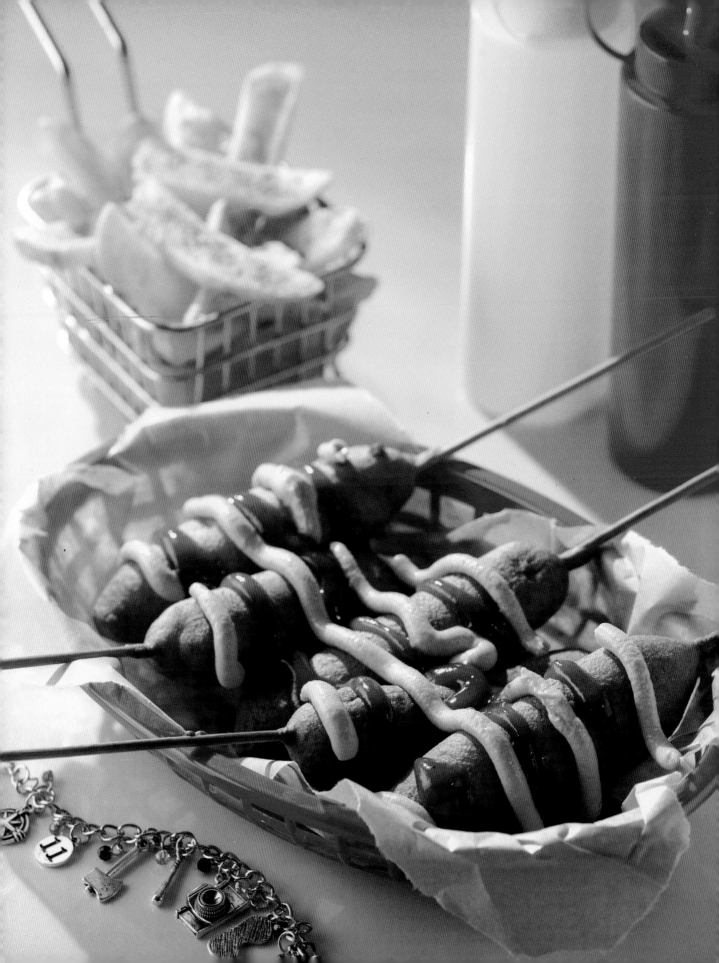

# Mini Corn
# DOGS

Now you can bring this food court classic right into your living room! Crispy corn dogs are traditionally served with mustard and ketchup, although you can top these mini corn dogs with any of your favorite sauces and dips.

## INGREDIENTS

MAKES 12

- ★ 12 small Vienna sausages
- ★ 1 cup (4½ oz/130 g) pastry flour, plus more for dusting
- ★ 1 cup (4½ oz/130 g) cornmeal
- ★ 1½ tsp baking powder
- ★ ½ tsp garlic powder
- ★ ½ tsp Cayenne pepper
- ★ 1 tsp sweet paprika
- ★ Salt
- ★ Sugar
- ★ 1 cup (8 fl oz/240 ml) buttermilk
- ★ 2 medium eggs
- ★ 2 tbsp neutral oil

Extras

- ★ 12 wooden skewers
- ★ 8½–12¾ cups (3½–5¼ pints/2–3 L) oil, for deep-frying
- ★ Mustard
- ★ Ketchup

## METHOD

Insert a skewer into each of the sausages and dust with a little flour.

In a bowl, mix the cornmeal with the flour, baking powder, garlic powder, Cayenne pepper, paprika, 1 teaspoon salt, and a pinch of sugar. Add the buttermilk, eggs, and oil and mix to a smooth and thick batter. If the batter is too runny, add more cornmeal. If it is too thick, incorporate a little more buttermilk. Pour the batter into a mixing beaker.

Heat the oil in a large pot. If you dip a wooden spoon into the oil and small bubbles rise from the handle, it is hot enough to use.

Dip the sausages in the batter until well coated. Drain briefly and then fry in the hot oil. Turn the corn dogs by the skewers as they fry so that they turn golden brown all over, about 2–3 minutes. Be careful of splashing oil!

Transfer the cooked corn dogs to a plate lined with paper towels. Serve with mustard and ketchup.

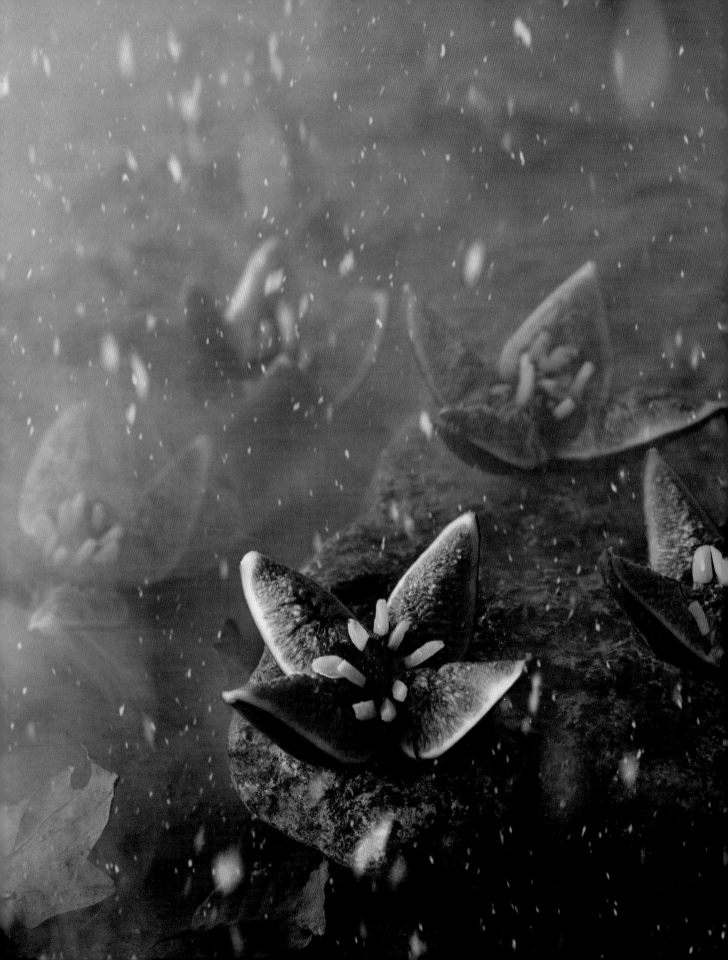

# Demogorgon FIGS

Facing a Demogorgon is not for the fainthearted. Running away isn't a good idea either. The best place for you to enjoy these scary sweet treats is in your favorite recliner watching TV.

## INGREDIENTS

MAKES 8

* 8 fresh figs
* 3½ oz (100g) dark chocolate couverture
* ½ cup (1¾ oz/50 g) slivered almonds

## METHOD

Wash the figs and pat dry with paper towels.

Without cutting all the way through, make five vertical cuts of the same length and equally spaced around each fig so that it will remain in one piece and open like a flower when the bottom half is gently squeezed.

Break or chop the chocolate into small pieces and melt in a bowl over a bain-marie or in the microwave for a few seconds, taking care that it doesn't overheat. Set aside and let cool slightly.

Carefully open the fig petals and add 1 tablespoon of warm chocolate to the center of each flower. Decorate with a few almond slivers to recreate Demogorgon teeth, and let dry for a few minutes before serving.

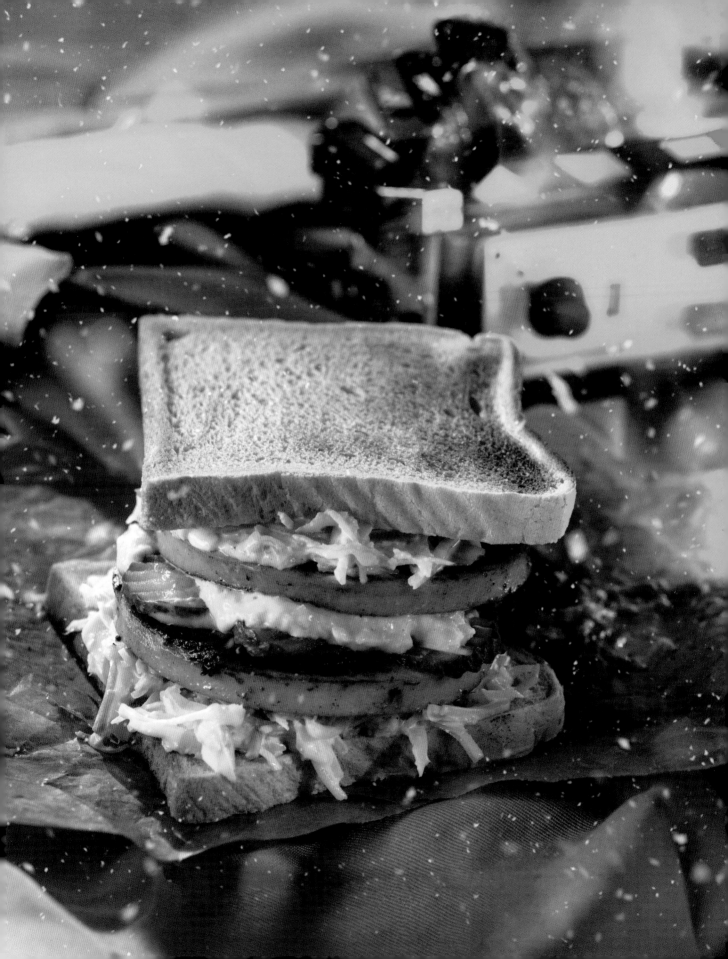

# Dustin's Bologna
# SANDWICH

Dustin loves to load up on Bologna sandwiches, especially because they have enough protein to keep him going during a long day of monster-hunting. Vary the fillings to your taste with sun-dried tomatoes, lettuce, and herbs. Of course, after eating all these sandwiches, Dustin will be too full for Mrs. Wheeler's famous meatloaf (p. 68).

## INGREDIENTS

SERVES 1

* 1 tbsp unsalted butter, plus more for spreading
* 2 thick slices Bologna sausage (alternatively, mortadella or fleischwurst)
* Salt, pepper
* 2 slices toasting bread
* Colorful Coleslaw (as needed, see recipe on p. 57)
* 6–8 dill pickles
* Sandwich Spread (ready-made product)

## METHOD

Melt the butter in a skillet over medium heat. Add the Bologna slices and fry, turning occasionally, about 3–5 minutes (depending on how thick the slices are). Season with salt and pepper, and transfer to a plate lined with paper towels.

Toast the two slices of bread in a toaster, spread butter on one side of each, and place one of the slices, butter side up, on a plate. Cover with a layer of coleslaw, a fried Bologna slice, and pickles, then top with a liberal serving of Sandwich Spread.

Over the Sandwich Spread place the second Bologna slice and make another layer of coleslaw. Cover with the second slice of toast. Press lightly and enjoy immediately.

# Starcourt Mall
# HOT DOG

A good food court hot dog is all about the toppings. Whether you cover it with classic caramelized onions or fiery hot homemade chili con carne, if you're going to do it, do it right.

## INGREDIENTS

MAKES 4 OF EACH

For the sweet onion dog

- ★ 2 tbsp (1 oz/30g) unsalted butter
- ★ 1 tbsp vegetable oil
- ★ 2 large onions
- ★ Salt
- ★ Scant ½ cup (3½ fl oz/ 100ml) dry hard cider
- ★ 1 tbsp apple cider vinegar
- ★ 1 tbsp cane sugar
- ★ 4 hot dogs
- ★ 4 hot dog buns
- ★ Sandwich Spread
- ★ Dill pickles, sliced
- ★ Spicy ketchup

For the chili dog

- ★ 1 tbsp oil
- ★ 5¼ oz (150g) ground pork
- ★ Salt, pepper
- ★ ⅔ cup (3½ oz/100 g) kidney beans

## METHOD

For the sweet onion dog:

Heat the butter and oil in a nonstick skillet over medium heat. Peel and slice the onions into rings. Add the onions to the hot pan, season with a pinch of salt, and let caramelize until golden brown, stirring from time to time, about 25–30 minutes. Deglaze with the cider, dissolving the caramelized juices on the surface of the pan. Simmer for another 10 minutes until the liquid has completely evaporated. Then remove from the heat, add the vinegar and sugar, and mix well.

Put the hot dogs into a pot of hot water and let stand for 5 minutes to heat through. In the meantime, toast the buns and cut them open lengthwise, without cutting all the way through so that the two halves are still joined. Transfer the sausages to a plate lined with paper towels.

Smear the inside of the buns with Sandwich Sauce and make a layer of pickles. Place a hot dog on top of the pickles, cover with caramelized onions, and finish with the ketchup. Gently press the bun closed and enjoy immediately.

For the chili dog:

Heat the oil in a nonstick skillet over medium heat. Add the meat, liberally season with salt and pepper, and sauté until crumbly, about 5 minutes. Add the beans and vegetable mix, stir to incorporate, and sauté for 5 more minutes. Mix in the salsa and simmer, stirring regularly, until the liquid has almost completely evaporated. Adjust the seasoning with salt and pepper.

Put the hot dogs into a pot of hot water and let stand for 5 minutes to heat through. In the meantime, toast the buns and cut them open lengthwise, without cutting all the way through so that the two halves are still joined. Transfer the sausages to a plate lined with paper towels. Wash and slice the chile into rings and set aside.

Spread cheese sauce inside the buns, add a sausage to each, and top with a generous serving of chili con carne. Add chile as desired. Gently press the bun closed and enjoy immediately.

- ★ ½ cup (3½ oz/100 g) Mexican vegetable mix (corn, peas, red bell pepper; from the can)
- ★ Scant ½ cup (3½ fl oz/100 ml) hot salsa (ready made product)
- ★ 4 hot dogs
- ★ 4 hot dog buns
- ★ 1 red chile pepper
- ★ Cheese sauce (ready-made product)

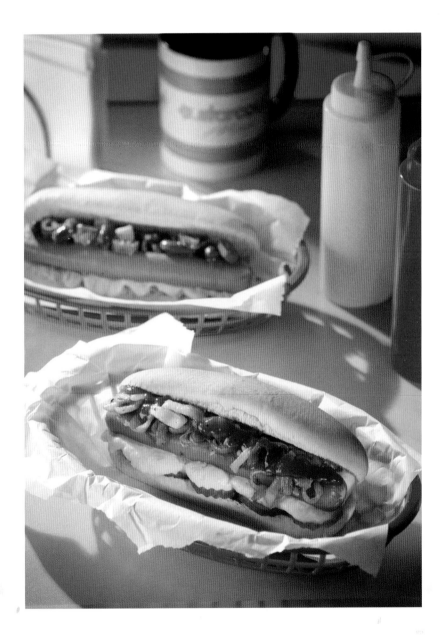

# POTATO CHIPS
## and Salsa

Why buy processed foods when your oven is capable of making the perfect movie-watching snack? The salsa is also a perfect dip for a wide range of snacks and will keep in the refrigerator for several weeks.

## INGREDIENTS

SERVES 4

For the salsa

* 14 oz (400 g) fresh tomatoes
* 1½ cloves garlic
* 1 red onion
* 1–2 green chile peppers
* 5 tsp (1½ fl oz/40 ml) olive oil, plus more for cooking
* Cane sugar
* 5 tsp (1½ fl oz/40 ml) apple cider vinegar
* 1 tbsp smoked paprika
* 1 tbsp ground cumin
* Salt, pepper
* Cayenne pepper

## METHOD

Wash the tomatoes, remove the stems, and finely dice. Peel and mince the garlic and onion. Wash and slice the chile into thin rings.

For the salsa, heat a little oil in a medium saucepan over medium heat. Add a third of the diced tomatoes, sprinkle with a pinch of sugar, and sauté until light, toasted aromas develop. Add the remaining tomatoes together with the garlic, onion, chile, vinegar, paprika, and cumin. Gently incorporate, cover, and let simmer until the tomatoes break down, about 5 minutes. Use an immersion blender if necessary. Liberally season with salt, pepper, and Cayenne pepper.

Transfer the salsa to a previously rinsed mason jar. Immediately close the jar and leave to cool to room temperature. Then refrigerate until ready to use. The salsa is best enjoyed slightly cold.

For the potato chips, preheat the oven to 350°F. Line a baking sheet with parchment paper.

Wash the potatoes thoroughly and use a mandoline to cut into about 2-mm-thick slices. Transfer the slices to a bowl, mix with the olive oil, 2 pinches of salt, 2 pinches of pepper, paprika, sugar, 2 pinches of chili powder, and the garlic powder until well coated with the seasoning.

Arrange the seasoned potato slices side by side on the baking sheet and bake for 30 minutes until crispy and golden brown. Carefully turn the chips over halfway through. Take the chips out of the oven and serve as soon as possible in individual bowls with the salsa for dipping.

## For the potato chips

- ★ 8–10 large waxy potatoes
- ★ ⅓ cup (3 fl oz/90 ml) olive oil
- ★ Salt, pepper
- ★ 2 tsp smoked paprika
- ★ 2 tsp cane sugar
- ★ Chili powder
- ★ 1 tsp garlic powder

## Extras

- ★ 1 mason jar (approx. 1⅔-cup/14-fl-oz/400-ml capacity)

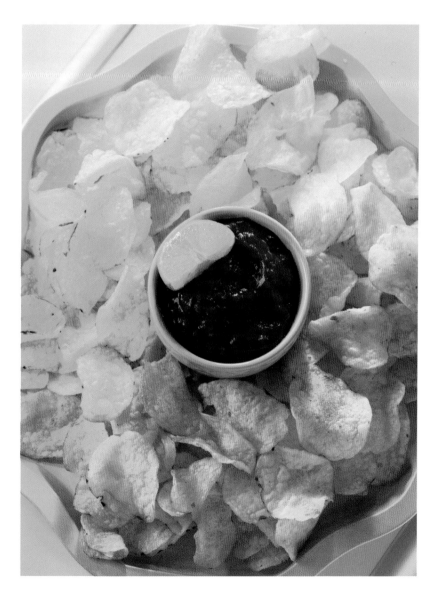

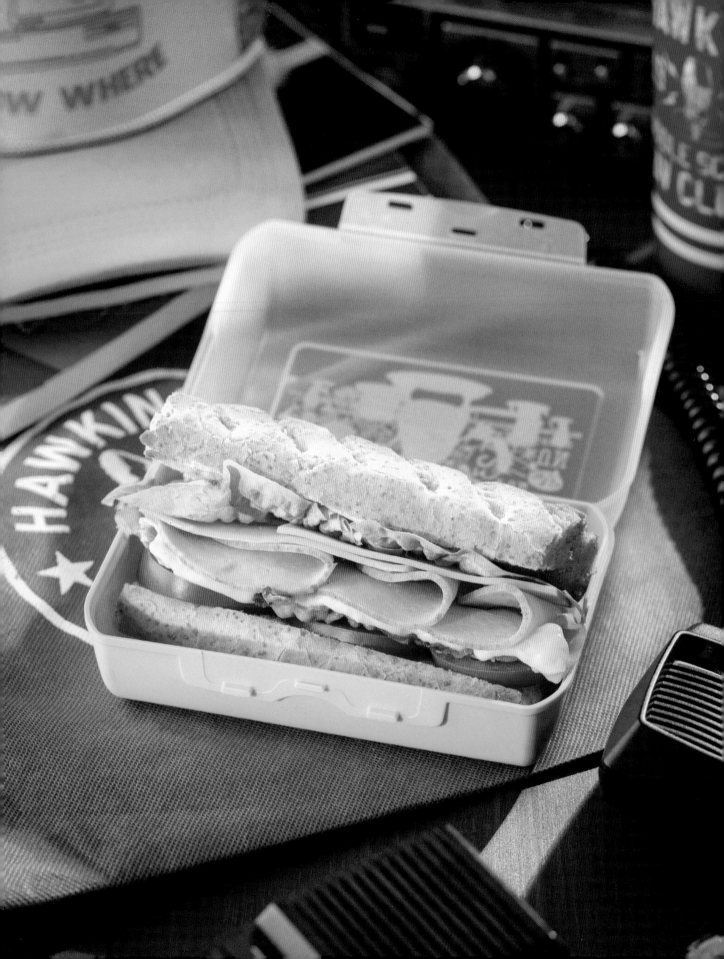

# Brown Bag Turkey
# SANDWICH

From Hawkins Middle School to your dining room table, this
turkey sandwich is a timeless lunchtime classic.

## INGREDIENTS

MAKES 2

* ★ 1 baguette
* ★ 2 large lettuce leaves
* ★ 1 large tomato
* ★ Unsalted butter
* ★ 4 slices bacon
* ★ 2 tbsp cream cheese
* ★ 5½ oz (160 g) smoked turkey breast
* ★ Cheddar cheese (slices)

## METHOD

Cut the baguette in half and slice each half down the center.

Wash the lettuce leaves and shake dry. Wash the tomato, remove the stem, and slice.

Melt a little butter in a nonstick skillet over medium heat. Fry the bacon on both sides until crispy, about 2–3 minutes per side. Then transfer to a plate lined with paper towels.

Spread the bottom part of the baguette halves with 1 tablespoon cream cheese. Then top with layers of tomato slices, bacon, cheddar slices, and turkey breast. Finally, cover with another layer of cheddar and then the lettuce. Cover the bottom of the sandwiches with the top.

Gently press and serve immediately.

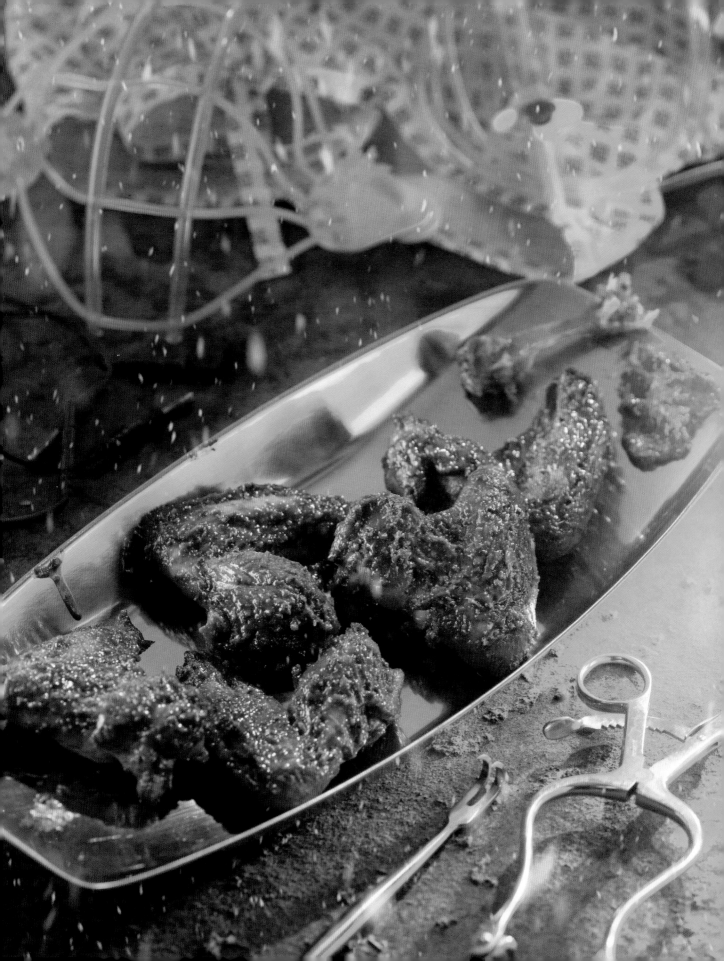

# Stranger WINGS

Chicken wings are easy to prepare and can be combined with different side dishes and dips. Be the champion of your next party and surprise your friends with a delicious hot snack fresh from the oven.

## INGREDIENTS

SERVES 4

- ★ 5 activated charcoal tablets
- ★ 1 tbsp dried sage
- ★ 1 tbsp dried rosemary
- ★ 2 tbsp dried thyme
- ★ 2 tbsp sweet paprika
- ★ 1 tbsp salt
- ★ 1 tbsp Cayenne pepper
- ★ Scant 1 cup (7 fl oz/ 200 ml) Teriyaki Sauce with Roasted Garlic (ready-made product)
- ★ Scant ½ cup (3½ fl oz/ 100 ml) soy sauce
- ★ Scant ¼ cup (1¾ fl oz/ 50 ml) buttermilk
- ★ 2¼ lb (1 kg) chicken wings

## METHOD

Use a mortar and pestle to grind the activated charcoal tablets to a fine powder. Alternatively, put the tablets into a freezer bag on a work surface and crush with a skillet. In a small bowl, carefully mix together the sage, rosemary, thyme, paprika, salt, Cayenne pepper, teriyaki sauce, soy sauce, buttermilk, and activated charcoal. Transfer to a resealable freezer bag.

Dry the chicken wings by patting with paper towels and add them to the bag with the marinade. Seal the bag, rub the marinade into the meat, and refrigerate for at least 3 hours, preferably overnight.

Take the marinated chicken wings out of the bag. Pour the marinade into a small saucepan and reduce over medium heat for 30 minutes, stirring constantly, to a dark and glossy glaze. Remove from the heat and let cool.

In the meantime, preheat the oven to 350°F. Position a rack on the middle oven rail and put a drip tray under it. Place a large bowl with an inch of water on the tray to catch the fat as it drips.

Liberally brush the chicken wings all over with the glaze and arrange them on the rack. Cover loosely with aluminum foil and cook in the oven (middle rack) for 40–45 minutes. Every 10 minutes, turn the wings over and brush with the glaze. Finally, brush the wings with the remaining glaze, take off the foil, and raise the oven temperature to 425°F for 5 minutes to crisp the skin. Then take them out of the oven and serve immediately.

# SIDE DISHES & ENTRÉES

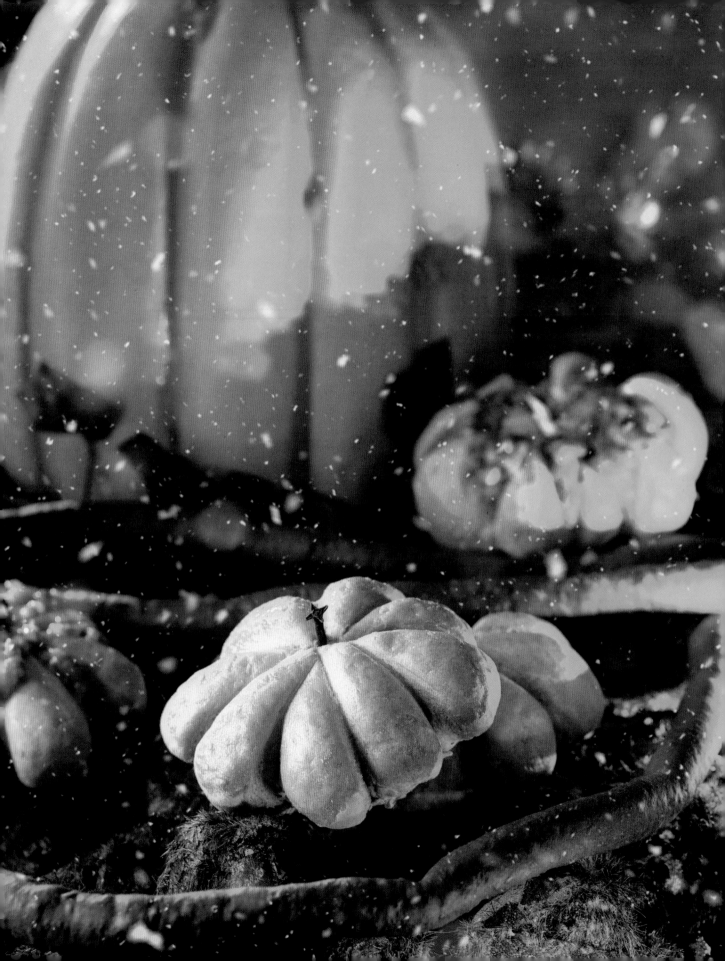

# Pumpkin ROLL

Fall has arrived in Hawkins! Whether for a birthday, a fancy Thanksgiving dinner, or a spooky Halloween party, these bread rolls make the perfect accompaniment to any menu. Mark the occasion by using them for creative burgers or give them creepy faces.

## INGREDIENTS

MAKES 8

* 3¾ cups (1 lb/450 g) pastry flour, plus more for rolling out dough
* 2¼ tsp instant yeast
* 1 tsp salt
* 1 tbsp sugar
* 1⅓ cups (10½ oz/ 300 g) pumpkin puree (from the jar)
* 1 medium egg

Extras
* Kitchen string

## METHOD

Line a baking sheet with parchment paper.

In a bowl, combine the flour with the yeast, salt, and sugar. Add the pumpkin puree and scant ½ cup (3½ fl oz/100 ml) of lukewarm water. Gently knead to a smooth dough. Cover with a clean kitchen towel and let rise in a warm place for 1 hour.

In the meantime, cut the string into eight 20-inch (50-cm) lengths.

Transfer the dough to a floured work surface and divide into 8 uniform pieces. Shape each piece into a ball. If the dough is too sticky, sprinkle with a little more flour.

Dust a string with a little flour and place the end, centered, under a ball of dough. Pull the string over the top. Then turn the ball over and repeat the process on the other side, and continue until the ball is divided into eight equal segments. Tie the string loosely as the dough will still need to rise further. Repeat the process with the other rolls. Place the rolls on the prepared baking sheet, cover, and let rise for 15 more minutes.

In the meantime, preheat the oven to 350°F (180°C, top and bottom heat).

In a small bowl, whisk the egg with 2 tablespoons of water and brush the rolls with the egg wash. Then bake, about 20 minutes. Take the rolls out of the oven and let cool for 30 minutes. Carefully remove the string.

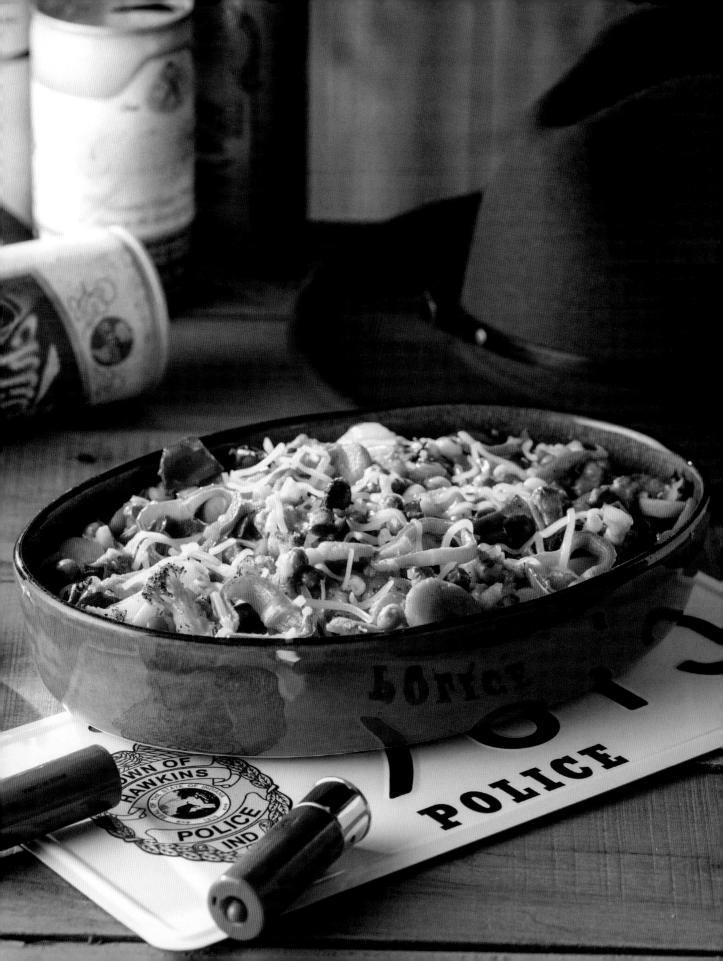

# Hopper's
# MIXED VEGETABLES

Even Eleven is impressed by this side dish; it's so unbeatable that you'll never have to worry about someone not wanting to finish their vegetables again. Vary the vegetables as they come into season, and you'll be surprised by the possible color combinations.

## INGREDIENTS

SERVES 4–5

* 2 tbsp unsalted butter, plus more for greasing
* 1 onion
* 2 cloves garlic
* 1 red bell pepper
* 6 cups (1¾ lb/800 g) frozen vegetables of your choice (e.g., peas, broccoli, carrots, etc.)
* 1 tbsp herbes de Provence
* 2 medium egg yolks
* Scant 1 cup (7 oz/200 g) crème fraîche
* Salt, pepper
* 2 cups shredded Gouda cheese

Extras

* Casserole dish (10 × 8 inches/25 × 20 cm)

## METHOD

Preheat the oven to 475°F. Liberally grease the casserole dish with the butter.

Peel and mince the onion and garlic. Wash, trim, and cut the bell pepper into strips.

Melt the butter in a nonstick skillet over medium heat. Add the onion and garlic and sweat for 2–3 minutes. Add the frozen vegetables and peppers, mix to combine, and cook, about 10 minutes, stirring regularly.

Remove the pan from the heat, stir in the herbs, egg yolks, and the crème fraîche, and liberally season with salt and pepper.

Transfer the vegetables to the baking dish, evening out and smoothing the surface, and sprinkle with the cheese. Cook in the oven until golden, and cheese becomes crispy about 6–8 minutes. Take the vegetables out of the oven and let cool for 5 minutes before serving.

# *colorful*
# COLESLAW

Add a bit of color to your plate! Cabbage is high in vitamins and fiber, and the perfect accompaniment for countless dishes. A treat for the eyes and the taste buds, this refreshing salad will make you the star of your next cookout.

## INGREDIENTS

SERVES 8–10

* ½ medium head (12½ oz/350 g) white cabbage
* ½ medium head (12½ oz/350 g) red cabbage
* Salt
* 6 medium (8¾ oz/ 250 g) carrots
* 1 apple
* 3 scallions
* ⅔ cup (5 fl oz/150 ml) buttermilk
* ⅔ cup (5¼ oz/150 g) mayonnaise
* 1 tbsp apple cider vinegar
* 1 tbsp honey
* 1 tbsp mustard
* Raisins (as needed)
* Pepper

## METHOD

Wash and trim both types of cabbage and then cut into thin strips and place in a large bowl with matching lid. Season liberally with salt, close the lid, and refrigerate for a few hours. Bear in mind that the longer the cabbage rests, the softer it will become.

In the meantime, wash, trim, and cut carrots, apple, and green onions into thin strips. Add to the cabbage and mix well.

In a bowl, whisk together the buttermilk, mayonnaise, apple cider vinegar, honey, and mustard. Pour the dressing over the coleslaw and mix until everything is well coated. Gently incorporate the raisins, season liberally with pepper, and refrigerate again for a few hours, preferably overnight.

Mix well again before serving. Coleslaw can keep in the refrigerator for up to 3 days.

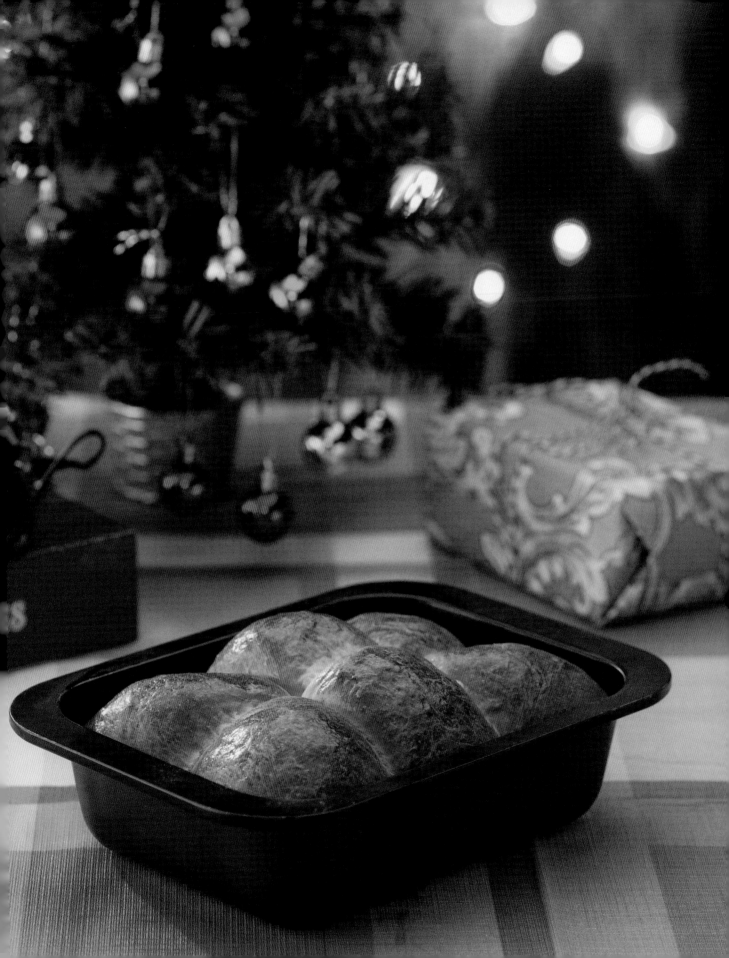

# Mrs. Wheeler's
# DINNER ROLLS

Delicious, airy, and easy to bake, Karen's dinner rolls will enhance any meal, whether it's a holiday menu or a casual dinner with friends and family. These rolls make sumptuous burger buns or they can be enjoyed as an accompaniment to any entrée.

## INGREDIENTS

SERVES 6–8

* 5 tbsp/⅓ cup (2½ oz/ 70 g) unsalted butter, plus more for greasing
* 4 cups (1 lb 2 oz/500 g) pastry flour
* 2¼ tsp instant yeast
* Generous 1 cup (8¾ fl oz/250 ml) milk
* 2 tsp salt
* ¼ cup (2 oz/55 g) sugar
* 2 medium egg yolks

Extras

* Casserole dish (8 x 12 inches/20 x 30 cm)

## METHOD

Melt the butter in a small saucepan over low heat. Set aside.

In a large bowl, combine the flour with the yeast.

Lightly heat the milk. Add the sugar, salt, lukewarm milk, egg yolks, and butter to the flour, incorporate, and use a hand mixer fitted with a dough hook to knead until the dough pulls away from the sides of the bowl (this may take a few minutes). Cover the dough with a clean kitchen towel and let rise for 1 hour in a warm place.

Grease the casserole dish with butter.

Divide the dough into 12 equal pieces and shape into balls. Line up the dough balls as evenly spaced as possible in the dish, cover, and let rise for 30 more minutes.

Preheat the oven to 410°F. Bake the rolls for 25–30 minutes, until golden brown.

Shortly before the end of the baking time, melt a little butter in a small saucepan. As soon as the dinner rolls come out of the oven, brush with the melted butter. Best served warm.

# Demogorgon PIZZA

When it's hungry the Demogorgon's terrifying face opens into a giant mouth hellbent on devouring anything that crosses its path. Here, the Demogorgon's fearsome mouth is recreated in bacon, but this time YOU get to bite back!

## INGREDIENTS

SERVES 4

For the pizza dough

* ★ 2⅓ small cakes (1½ oz/40 g) fresh yeast
* ★ 2 tbsp (1 oz/30 ml) olive oil
* ★ Sugar
* ★ Salt
* ★ 7⅓ cups (2½ lb/925 g) all-purpose flour, plus more for rolling out dough

For the tomato sauce

* ★ 1⅔ cups (14 oz/400 g) chopped tomatoes (from a can)
* ★ 2 tbsp tomato paste
* ★ Sugar
* ★ Salt, pepper
* ★ 1 tbsp Italian herbs

For the topping

* ★ 1 cup (5½ oz/160 g) pitted black olives (from a jar)
* ★ 7 oz (200 g) salami
* ★ 5¼ oz (150 g) bacon
* ★ 1¾ cups (7 oz/200 g) shredded mozzarella cheese

## METHOD

For the pizza dough, mix the yeast, olive oil, a pinch of sugar, 1 tablespoon (¾ oz/20 g) of salt, and 2 cups plus 2 tablespoons (17 fl oz/500 ml) lukewarm water in a bowl until the yeast, sugar, and salt are completely dissolved. Add the flour, incorporate, and knead well with your hands until the dough can be shaped into a ball. Add a little more flour or water if necessary, depending on whether the dough is too sticky or too compact. Cover with a clean kitchen towel and let rise in a warm place, about 30 minutes, or until the dough has doubled in size.

Meanwhile, to make the tomato sauce, mix the tomatoes, tomato paste, a pinch of sugar, 1 teaspoon each salt and pepper, and the herbs in a saucepan and bring to a boil over medium heat for a short time, stirring constantly. Remove from the heat and set aside.

Vigorously knead the risen dough, cover again with the cloth, and let rise again for 2 more hours at room temperature. Alternatively, refrigerate overnight.

Preheat the oven to 350°F. Line two baking sheets with parchment paper.

Halve the olives and cut the salami into strips.

Divide the pizza dough into four equal portions. Roll out each piece of dough on a lightly floured work surface with a rolling pin and then place on the baking sheets. Place a small, inverted bowl in the center of each pizza and make cuts in the dough around it to form the shape of a five-petal flower. Cut off the excess. Roll the edges of the dough under the petals. Roll up the excess dough, and then cut into about ½-inch (1-cm) pieces. Arrange these pieces around the bowl as teeth. Remove the bowl.

Spread tomato sauce over the pizza. Complete the mouth by arranging two rolled-up bacon slices in the center. Scatter over with half of the cheese.

Arrange the salami and olives on the petals to resemble the Demogorgon as closely as possible. Sprinkle with the remaining cheese.

Bake the pizzas, about 15–20 minutes, or until the edges of the pizzas turn golden brown.

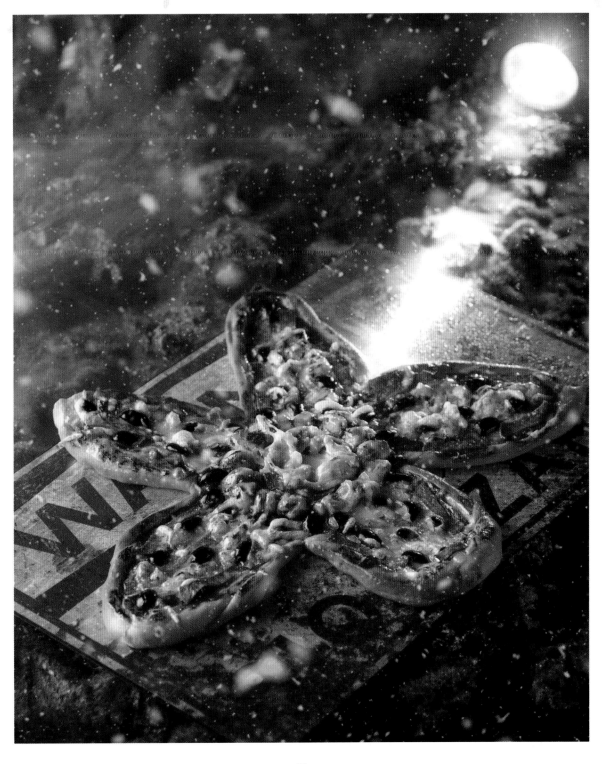

# *Joyce's*
# VEGETABLE LASAGNA

Bring variety to the dining table with colorful seasonal vegetables.
Packed with enough vegetables to satisfy both Will and Jonathan,
Joyce's vegetable lasagna is a filling meal after a long day.

## INGREDIENTS

SERVES 2–3

For the vegetables

* 1¼ cups (5¼ oz/150 g) frozen carrots
* ⅔ cup (3½ oz/100 g) frozen peas
* 1 large (5¼ oz/150 g) onion
* 2 cloves garlic
* 7 oz (200 g) white button mushrooms
* 1 red bell pepper and 1 yellow bell pepper
* 2 tbsp oil
* 1 tbsp sugar
* ¾ cup (7 oz/200 g) chopped tomatoes (from a can)
* Salt, pepper

## METHOD

Let the carrots and peas thaw slightly. Peel and mince the onion and garlic. Clean, trim, and thinly slice the mushrooms. Wash, trim, and cut the bell pepper into thin strips.

Pour the oil into a nonstick skillet over medium heat. Add the onion and garlic to the hot oil, sprinkle with sugar, and sauté for 2–3 minutes. Add the mushrooms, carrots, peas, and peppers and sauté for about 4–5 minutes, until the vegetables are soft. Then add the chopped tomatoes, incorporate, and bring briefly to a boil. Season liberally with salt and pepper.

Melt the butter in a medium saucepan over medium heat. Sprinkle in the flour, mix with the butter, and toast lightly. Gradually stir in the vegetable broth and milk and continue to stir until all the liquid is absorbed and the sauce has a creamy consistency. Stir in the herbs and simmer for 5 minutes, stirring constantly. Add scant ½ cup (1¾ oz/50 g) cheese and stir in until completely melted and incorporated. Remove the pan from the heat and season with salt, pepper, and nutmeg.

Preheat the oven to 425°F.

Grease the casserole dish with butter and line the bottom with lasagna sheets, keeping flush. Spread a little béchamel over the pasta and cover with a layer of vegetables, followed by another layer of lasagna sheets. Repeat the process until the dish is almost full. Finish with a layer of sauce and vegetables, and sprinkle with an even layer of the remaining cheese.

Bake the lasagna in the oven, about 35 minutes. Take it out of the oven, let cool for a few minutes, and sprinkle with dried marjoram before serving.

For the béchamel sauce

- ★ 2 tbsp (1 oz/30 g) unsalted butter, plus more for greasing
- ★ ¼ cup (1 oz/30 g) pastry flour
- ★ ⅔ cup (5 fl oz/150 ml) vegetable broth
- ★ 1¼ cups (10 fl oz/ 300 ml) milk
- ★ 1–2 tsp herbes de Provence
- ★ 1⅓ cups (5¼ oz/150 g) shredded Gouda cheese
- ★ Salt, pepper
- ★ 1 tsp freshly grated nutmeg

Extras

- ★ Casserole dish (8 × 5½ inches/20 × 14 cm)
- ★ Lasagna sheets (depending on the size of the casserole dish)
- ★ Dried marjoram, for garnishing

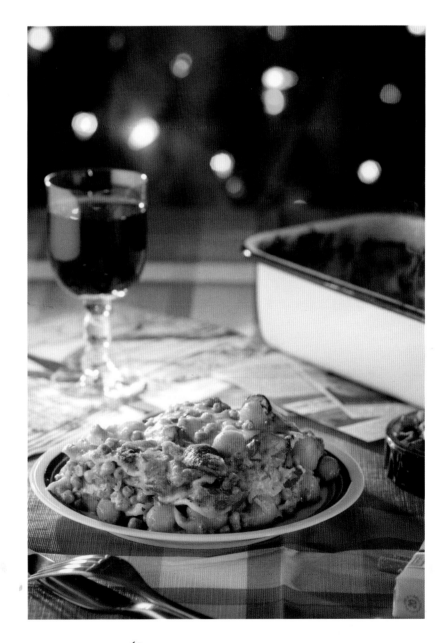

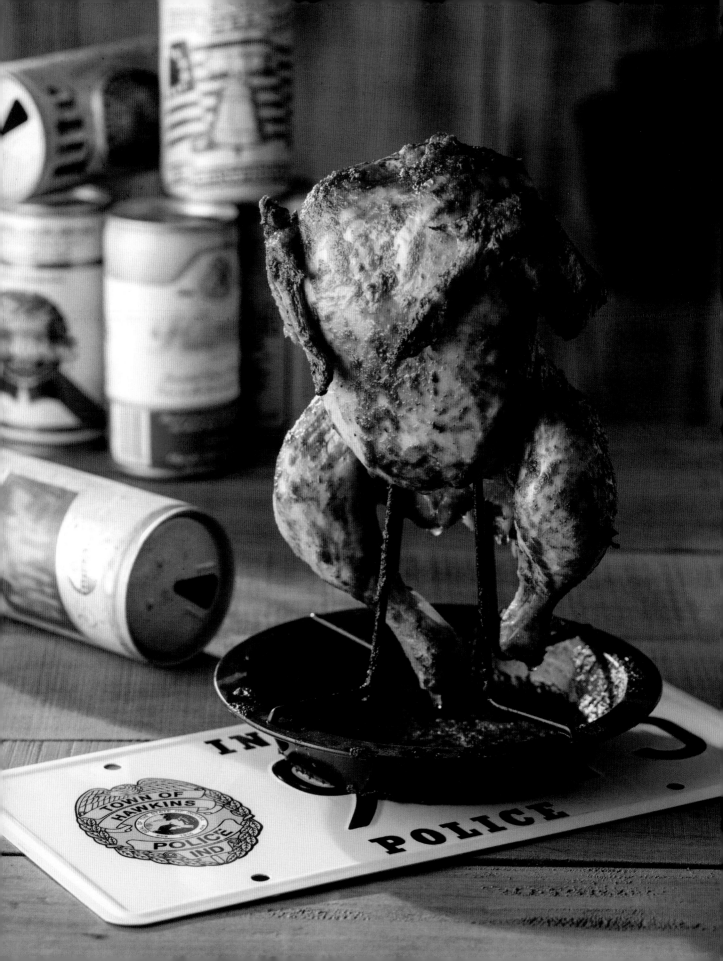

# *Hopper's*
# BEER CAN CHICKEN

With its crispy skin and tender and juicy meat, this chicken
is the perfect meal for an evening of sitting back and falling
asleep in front of the TV.

## INGREDIENTS

MAKES 1

★ 1 tsp paprika

★ 1 tsp dried thyme

★ 1 tsp black pepper

★ ½ tsp Cayenne pepper

★ 2 tsp salt

★ 2 tsp garlic powder

★ 2 tsp onion powder

★ 1 (about 4-lb 6-oz/2-kg) whole chicken

★ 1 can (1½ cups/12 fl oz/350 ml) lager beer

★ Generous 1 cup (8¾ fl oz/250 ml) chicken stock (optional)

## METHOD

Preheat the oven to 400°F.

Mix the spices together in a small bowl.

If not already dressed, remove and discard the chicken neck and entrails. Wash the chicken with cold water and pat dry.

Pour out (or drink) half of the beer. Place the can with the remaining beer in the middle of a high-sided ovenproof dish or roasting pan, then carefully lower the chicken cavity onto the can so that it is standing upright. Rub the chicken all over with the spice mix.

Loosely cover with aluminum foil and roast for 45 minutes. Remove the foil, brush with the juices released by the chicken, or with chicken stock, and cook for another 45 minutes, until the internal temperature of the thickest part of the chicken reaches 180°F (82°C). Baste from time to time with the juices or stock.

Take the chicken out of the oven and transfer to a cutting board. Let rest for at least 10 minutes before carving.

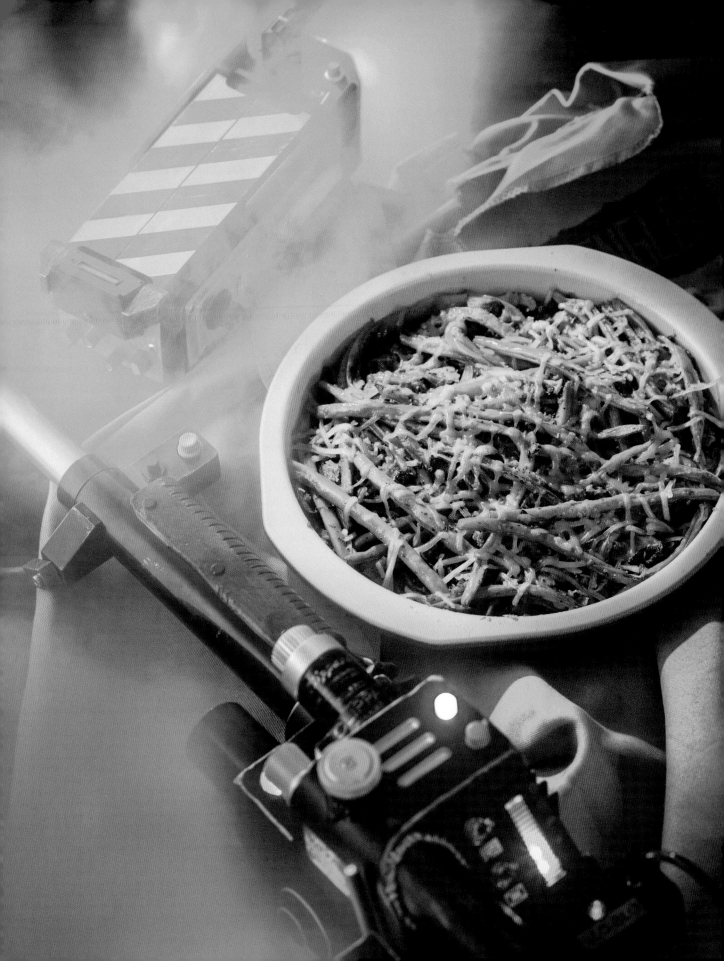

# Mrs. Wheeler's Condolence
# CASSEROLE

This delicious green bean casserole is the perfect comfort food. That's why Karen Wheeler and Holly visited Joyce while Will was missing with this wholesome offering. And like Mrs. Wheeler, you can make this casserole as a way to show your loved ones how much you care.

## INGREDIENTS

SERVES 5–6

* 7 cups (1½ lb/700 g) green beans
* ¼ cup (3⁄8 oz/10 g) savory
* Salt
* 7 oz (200 g) shallots
* 1 clove garlic
* 8¾ oz (250 g) white button mushrooms
* 5 tbps/⅓ cup (2½ oz/70 g) unsalted butter
* ⅓ cup (1¾ oz/50 g) diced ham
* Scant ⅔ cup (2½ oz/70 g) pastry flour
* 1⅔ cups (14 fl oz/400 ml) vegetable broth
* Scant 1 cup (7 oz/200 g) light cream
* 10 g dried rosemary
* ½ tsp sugar
* ¼ tsp freshly grated nutmeg
* Pepper
* Scant 1 cup (3½ oz/100 g) shredded cheese

## METHOD

Wash and dry the green beans and then top and tail with a small, sharp knife.

Fill a large bowl with cold water and ice cubes.

Put half of the savory into a large pot of heavily salted water and bring to a boil. Add the green beans and boil for 2 minutes. Use a slotted spoon to take the beans out of the pot, shock in the ice bath, and then set aside.

Peel and mince the shallots and garlic. Clean and quarter the mushrooms.

Preheat the oven to 400°F.

Melt the butter in a large pot over medium heat. Sauté the ham cubes until golden brown all over, about 3 minutes. Add the shallots and garlic and sweat for 2 minutes. Add the mushrooms, mix well, and cook for 4–6 minutes, until the mushrooms no longer release any liquid. Sprinkle with a little flour and cook for 4–6 minutes, stirring constantly. Deglaze the pot with the vegetable broth, pour in the cream, and add the savory, rosemary, sugar, and nutmeg. Raise the heat and cook for 5–6 minutes until thick. Season liberally with salt and pepper. Add the green beans to the pot, mix well, and cook for 5 more minutes.

Transfer the bean and mushroom mixture to a casserole dish, sprinkle with the cheese and bake, about 5 minutes, or until the cheese is melted and golden brown. Take the casserole out of the oven and let cool for a few minutes before serving.

Extras

* Ice cubes
* Casserole dish (8 x 10 inches/20 x 25 cm)

# Mrs. Wheeler's
# MEATLOAF

Mrs. Wheeler's meatloaf recipe creates just enough portions for everyone at the Wheeler's kitchen table. Accompany it with Karen Wheeler's recommended side dishes, and even your friends will be coming over for helpings of this filling classic.

## INGREDIENTS

SERVES 4

For the meatloaf

* 2 onions
* 1¾ slices (1¾ oz/50 g) bread
* 1 bunch flat-leaf parsley
* 1 tbsp unsalted butter, plus more for greasing
* 1 tbsp dried marjoram
* Salt, pepper
* 1¾ lb (800 g) pork sausage
* 1 medium egg
* 7 oz (200 g) bacon
* 10½ oz (300 g) raclette cheese

For the mashed potatoes

* 1¾ lb (800 g) floury potatoes
* Salt
* ⅔ cup (5 fl oz/150 ml) milk
* Scant ½ cup (3½ oz/ 100 g) cream

## METHOD

For the meatloaf, peel and mince the onions. Cut the bread into cubes. Wash, shake dry, and mince the parsley. Melt the butter in a skillet over medium heat. Add the onions and sauté for 5 minutes. Add the bread, parsley, and marjoram, season with salt and pepper, mix and sauté together. Remove from the heat and let cool slightly. Put the mixture in a bowl with the sausage. Add the egg, and vigorously knead the mixture with your hands.

Preheat the oven to 350°F.

Grease the loaf pan with butter. Line the pan fully with overlapping bacon strips. Spread one third of the meatloaf mixture inside the pan. Cut the cheese into thin strips and arrange lengthwise down the center of the pan. Repeat the process with a third of the mixture and the remaining cheese, and cover with the remaining meat. Fold any protruding bacon strips over the meat.

Bake the meatloaf in the oven, about 45 minutes. Then carefully pour off the juices from the pan into a small saucepan. Loosely cover the meatloaf with aluminum foil and keep warm in the oven until ready to serve.

For the mashed potatoes, peel and quarter the potatoes. Bring salted water to a boil in a large pot over medium heat. Add the potatoes and boil for 30 minutes. Pour off the water. Transfer the potatoes to a bowl, let steam, and then roughly mash with a potato masher. The mashed potatoes should have a chunky consistency.

Add the milk, cream, and butter in small pieces to the bowl and mix until the mashed potatoes are still quite chunky, but nice and creamy. Season with salt, pepper, and a pinch of nutmeg.

For the green beans and ham, clean and top and tail the beans. Bring salted water to a boil in a pot. Add the green beans and boil for 5 minutes.

Drain in a colander or sieve. Peel and mince the shallot. Melt the butter in a large skillet over medium heat. Add the diced ham, shallot, and savory and sauté, stirring occasionally. Add the beans and mix well. Season with pepper and salt and cook for 10–15 minutes over low heat.

For the sauce, combine the white wine and beef stock in a small saucepan with the meatloaf pan juices and bring to a boil over medium heat. Add a little gravy mix and bring to the boil briefly to thicken the sauce. Finally, stir in the cream.

- 5 tbsp/⅓ cup (2½ oz/ 70g) unsalted butter
- Salt, freshly ground black pepper
- Freshly grated nutmeg

For the green beans and ham
- 5 cups (1 lb 2 oz/500g) green beans
- Salt
- 1 shallot
- 2 tbsp (1 oz/30g) unsalted butter
- ⅔ cup (3½ oz/100g) diced ham
- 1 tbsp savory
- Pepper

For the sauce
- Scant ½ cup (3 fl oz/ 100ml) white wine
- Scant ½ cup (3½ fl oz/ 100 ml) beef stock
- Brown gravy mix
- 3 tbsp light cream

Extras
- Loaf pan (approx. 6⅓-cup/2⅔-pint/1.5-L capacity)

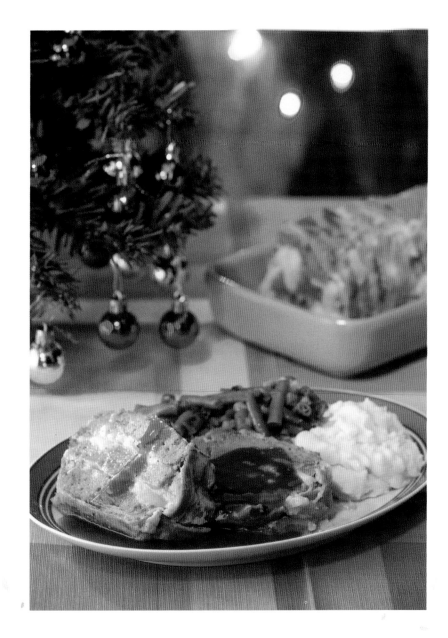

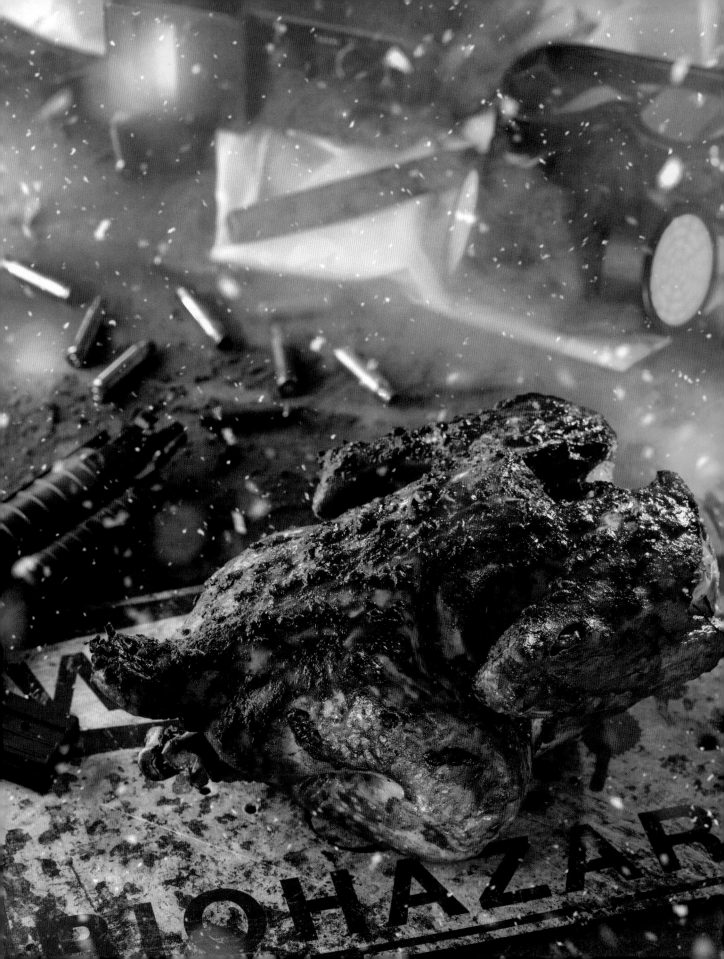

# *Stranger* **TURKEY**

The perfect turkey has crispy skin, juicy meat, and a fruity stuffing. It's a challenge to which only a few cooks rise up to meet. But this delicious recipe will prove to you that you don't have to be a Karen Wheeler in the kitchen to create a delicious roast.

## INGREDIENTS

SERVES 6–8

* ⭑ 1 shallot
* ⭑ 2 cloves garlic
* ⭑ ¼ bunch parsley
* ⭑ ½ apple
* ⭑ Pepper
* ⭑ 8¾ oz (250 g) pork sausage
* ⭑ 3 tbsp olive oil
* ⭑ 2 tbsp chicken seasoning blend
* ⭑ 5 tbsp Teriyaki Sauce with Roasted Garlic (ready-made product)
* ⭑ 1 (about 8¾-lb/4-kg) turkey, dressed

## METHOD

Peel and mince the shallot and garlic. Wash, shake dry, pluck, and mince the parsley. Wash, peel, and finely grate half the apple. Make the stuffing by mixing together the shallot, garlic, parsley, grated apple, a pinch of pepper, and pork sausage in a bowl.

Preheat the oven to 350°F. Place a large bowl with a little water in the oven to catch the fat as it drips from the turkey when roasting.

Mix the olive oil, chicken seasoning, and teriyaki sauce in a small bowl.

Pat the turkey dry with paper towels and fill the cavity with the stuffing. Close the opening with toothpicks, place the bird on a roasting rack, and rub all over with the teriyaki marinade.

Then put the turkey into the hot oven (bottom rack) and roast for 4–5 hours, depending on the weight. To calculate the cooking time, allow about 1 hour per 2¼ pounds (1 kilogram). Baste the turkey liberally by brushing with the remaining marinade and liquid from the bowl every 15–20 minutes. The turkey is done when the internal temperature of the thickest part of the breast reaches 176°F (80°C). Just before the turkey finishes roasting, brush with the remaining marinade and increase the temperature to 450°F (230°C, top and bottom heat) for 5 minutes. Then take the turkey out of the oven and transfer to a large, high-sided dish as it will still be releasing plenty of delicious juices. Let rest for at least 5 minutes before carving.

# Upside Down
# BURGER

The parallel universe known as the Upside Down is quite literally turning the small town of Hawkins on its head. Although it seems to be a reflection of the real world, something is wrong here, even with the food—see for yourself!

## INGREDIENTS

SERVES 4

For the patties
* 2¼ lb (1 kg) ground beef
* 3 tbsp teriyaki sauce (ready-made product)
* 2 tbsp onion powder
* 2 tbsp garlic powder
* 1 tbsp salt
* 1 medium egg
* Freshly ground pepper
* 1 tbsp vegetable oil

For the special sauce
* Generous 1 cup (8¾ fl oz/250 ml) ketchup
* ¼ cup (1¾ oz/50 g) cane sugar
* 5 tbsp medium-strength mustard
* 1 tbsp apple cider vinegar

## METHOD

Mix the ground beef in a bowl with teriyaki sauce, onion powder, garlic powder, salt, egg, and a little pepper. Refrigerate for 15 minutes.

In the meantime, make the special sauce. In a small saucepan over low heat, combine the ketchup, sugar, mustard, and vinegar. Simmer, stirring constantly, until the sugar is completely dissolved. Remove from the heat and set aside.

Wash and shake dry the lettuce leaves. Wash the tomato, remove the stem, and slice. Peel and slice the onion into rings.

Shape the meat into four large patties of uniform size. Heat the oil in a skillet and sear the patties over medium-high heat for 3 minutes on each side. Season with salt and pepper. Transfer to a plate lined with paper towels.

Slice open the burger buns and briefly toast the cut surfaces. Turn the top half of the buns upside down and assemble each burger by adding in the following order: rémoulade sauce, a lettuce leaf, tomato slices, onions, and pickles. Cover with a layer of special sauce and top with fried onions and a patty. Place a slice of cheddar on the patty and add cheese sauce. Cover with the bottom half of the bun and gently press.

For thick-cut fries, peel and cut the potatoes into 2–3-cm-wide strips. Soak the potatoes in iced water for 10 minutes to remove starch.

Put the oil in a high-sided pot over high heat and heat to 325°F. To test whether the oil is hot enough, drop in a potato strip. If it sizzles and bubbles, it's ready. Then take the potatoes out of the water, thoroughly pat dry with paper towels, and deep-fry in several batches for 4–5 minutes.

Then raise the temperature of the oil to 375°F. Fry the potatoes a second time until the fries are crisp and golden brown. Take the finished fries out of the oil, drain on a plate lined with paper towels, and transfer to a bowl. Toss with French fry seasoning to taste.

### For the burgers

* 4–8 lettuce leaves
* 1 large tomato
* 1 red onion
* 4 burger buns
* Rémoulade sauce (ready-made product)
* Dill pickles, sliced
* Fried onions (ready-made product)
* 4 cheddar cheese slices
* Cheese sauce (ready-made product)

### For the thick-cut fries

* 2¼ lb (1 kg) floury potatoes
* Oil, for deep-frying
* French fry seasoning (as needed)

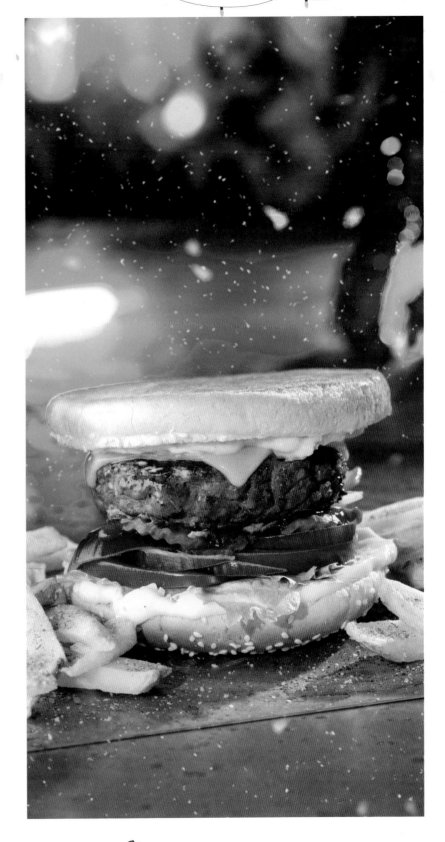

# *Chicken and*
# TATER TOTS

Mrs. Wheeler also often prepares this classic of American home cooking for her family. Karen's famous dinner rolls (see recipe on p. 59) make a great accompaniment to this satisfying casserole.

## INGREDIENTS

MAKES 6

- ★ 2 shallots
- ★ 4 tbsp unsalted butter
- ★ ½ tbsp dried thyme
- ★ ½ tbsp garlic powder
- ★ ⅓ cup (1½ oz/40 g) pastry flour
- ★ Generous 2 cups (16 fl oz/500 ml) chicken stock
- ★ Scant ½ cup (100 g) cream cheese
- ★ 1 lb 2 oz (500 g) frozen precooked chicken meat
- ★ 2½ cups (12½ oz/350 g) frozen mixed vegetables
- ★ 1¾ lb (800 g) frozen round potato croquettes
- ★ 5¼-oz (150-g) block cheddar cheese
- ★ Herbes de Provence (as needed)

Extras

- ★ Casserole dish (12 × 8¾ inches/30 × 22 cm)
- ★ Nonstick cooking spray

## METHOD

Preheat the oven to 400°F. Spray the casserole dish with nonstick spray.

Peel and mince the shallots. Melt the butter in a saucepan over medium heat. Add the shallots and sauté until translucent, stirring occasionally, about 4 minutes. Add the thyme, garlic powder, and flour. Mix well and sauté for 1–2 minutes, stirring constantly, or until everything turns deep golden brown. Then deglaze with the chicken stock and let simmer for 1 minute. Remove from the heat.

Mix in the cream cheese until completely melted. Add the frozen chicken and vegetables, mix well, and transfer the mixture to the prepared casserole dish, spreading evenly and smoothing the surface.

Cover with a layer of frozen croquettes, making sure there are no gaps between them. Bake in the hot oven (middle rack) for 35–40 minutes until the croquettes turn golden brown. In the meantime, grate the cheddar cheese. Then sprinkle the casserole with cheddar and herbes de Provence as desired. Return the casserole to the oven for 2–4 minutes until the cheese is melted.

Let cool a little before serving.

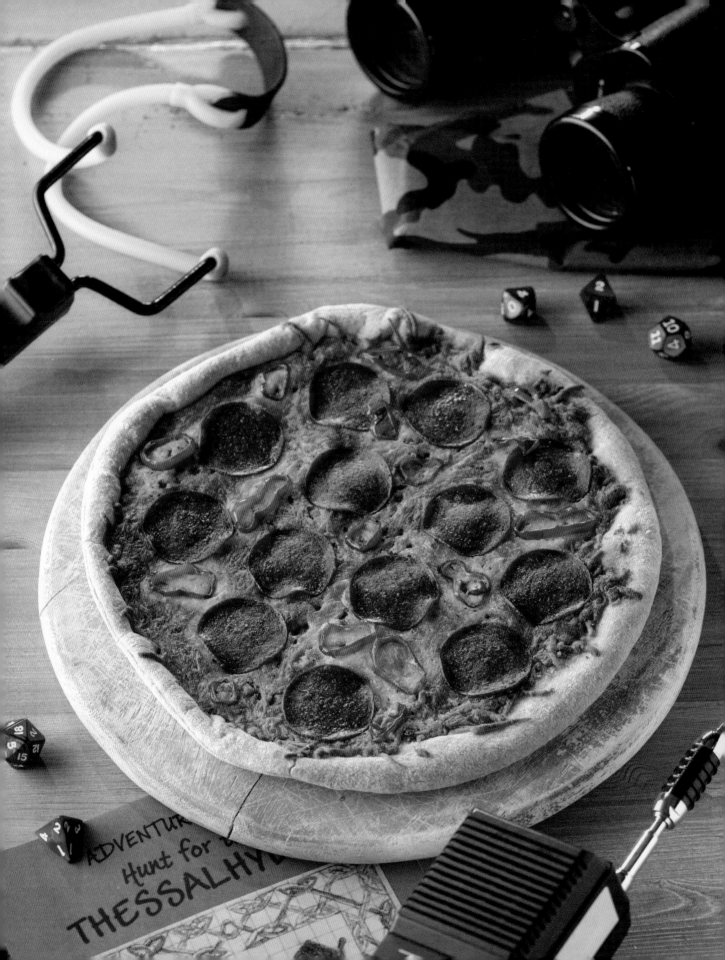

# Fiery Pepperoni
# PIZZA

Give your pizza an extra kick with these fiery toppings. Serve this at your next game night with your own Party and there won't be a single piece left by the end of the game.

## INGREDIENTS

MAKES 2

- ★ 1 tbsp olive oil
- ★ 1 shallot
- ★ 1 clove garlic
- ★ 1¼ cups (10½ oz/ 300 g) chopped tomatoes (from a can)
- ★ 1 dash balsamic vinegar
- ★ Salt, pepper
- ★ 2 tbsp Italian herbs
- ★ 1 red banana pepper
- ★ 1 lb 2 oz (500 g) ready-made pizza dough (from the refrigerated section of your supermarket)
- ★ Pastry flour for rolling out dough
- ★ 5¼ oz (150 g) pepperoni
- ★ 1¾ cups (200 g) shredded cheese

## METHOD

Peel and mince the shallot and garlic. In a saucepan, sauté the shallot and garlic in the olive oil over medium heat. Add the chopped tomatoes, bring to the boil briefly, and simmer for 5 minutes, stirring regularly. Season with the balsamic vinegar, salt, pepper, and Italian herbs. Remove from the heat and set aside.

Trim, wash, and finely slice the pepper.

Divide the pizza dough into two equal portions. Roll each portion out as thinly as possible on a lightly floured work surface to make two 24-cm-diameter disks.

Preheat the oven to 400°F. Line two pizza pans (or baking sheets) with parchment paper.

Place the pizzas on the pans, spread evenly with the tomato sauce, and top with the peppers and salami as desired.

Cover with a liberal sprinkling of cheese and bake for 12–14 minutes. Serve immediately.

## STRANGER TIP

If you like your pizza with an extra kick, you can substitute a red chile pepper for the banana pepper.

# DESSERTS

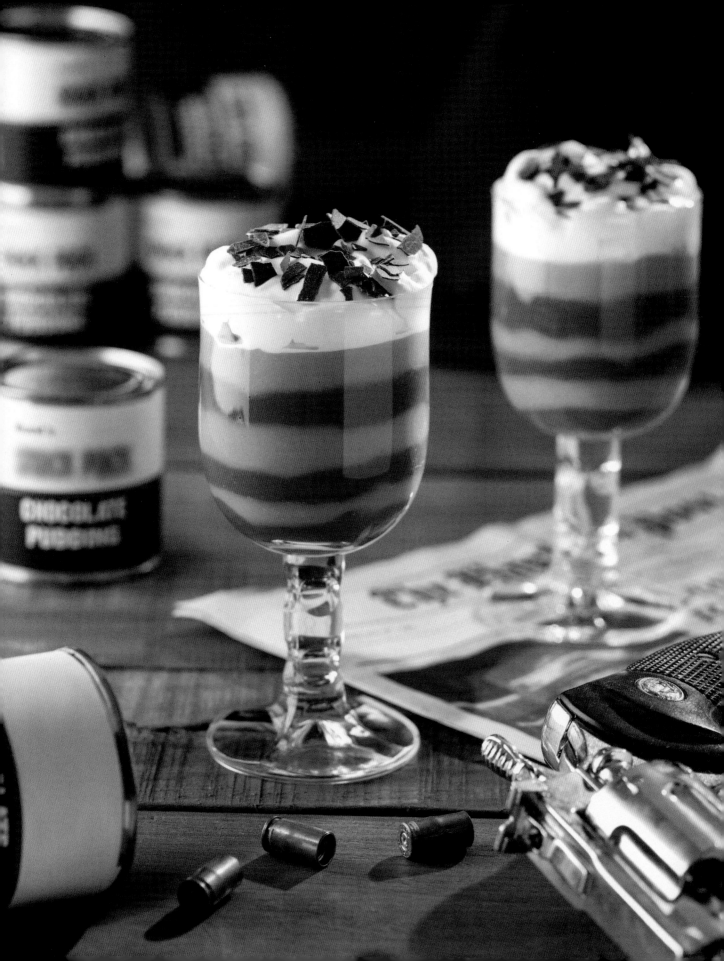

# *chocolate* PUDDING

What Mike, Dustin, and Lucas usually only know as a gooey mass would be a melt-in-the-mouth, chocolaty treat if they made it themselves. It would even be worth breaking into the school cafeteria for.

## INGREDIENTS

MAKES 6

For the caramel pudding
* 2 tsp (⅜ oz/10 g) unsalted butter
* 3 tbsp (1½ oz/40 g) cane sugar
* 2½ tbsp (¾ oz/20 g) cornstarch
* Scant 1 cup (7 fl oz/ 200 ml) milk
* Scant ½ cup (100 g) cream
* 2 tsp vanilla sugar
* Salt

For the mocha pudding
* Scant ½ cup (3½ fl oz/ 100 ml) strong espresso coffee, cold
* Scant 1 cup (7 fl oz/200 ml) milk
* 3½ tbsp (1½ oz/40 g) sugar
* 2½ tbsp (¾ oz/20 g) cornstarch
* 1 tsp cocoa powder

Extras
* Scant ½ cup (3½ oz/100 g) whipping cream
* Chocolate shavings, for decoration

## METHOD

For the caramel pudding, melt the butter in a saucepan and add the sugar. Let caramelize over medium heat, stirring regularly.

In the meantime, combine the cornstarch with some of the milk in a medium bowl and whisk until smooth.

When the sugar has caramelized and turned golden brown, add the remaining milk to the pan. Stir to dissolve the caramel. Stir in the cream, add the vanilla sugar and a pinch of salt, and then simmer for 3 minutes.

Add the cornstarch mixture to the pot and bring to a boil, stirring constantly, until the mixture thickens. Cook for 1 more minute, then remove from the heat, and cover with plastic wrap in direct contact with the pudding to prevent a skin from forming. Let cool.

For the mocha pudding, mix the coffee with the milk in a medium bowl. In a small saucepan, bring two-thirds of the mixture to a boil over medium heat.

Add the sugar, cornstarch, and cocoa to the remaining coffee mixture and whisk until lump free. Then add this mixture to the pan and bring to a boil, stirring, about 1 minute. Remove from heat and cover the pudding with plastic wrap to prevent a skin from forming. Let cool.

To serve, stir the two cooled puddings to smooth, and then layer alternately in dessert glasses. Refrigerate for at least 2 hours. Whip the cream until stiff peaks form, then add to each glass as the last layer, and decorate with chocolate shavings as desired.

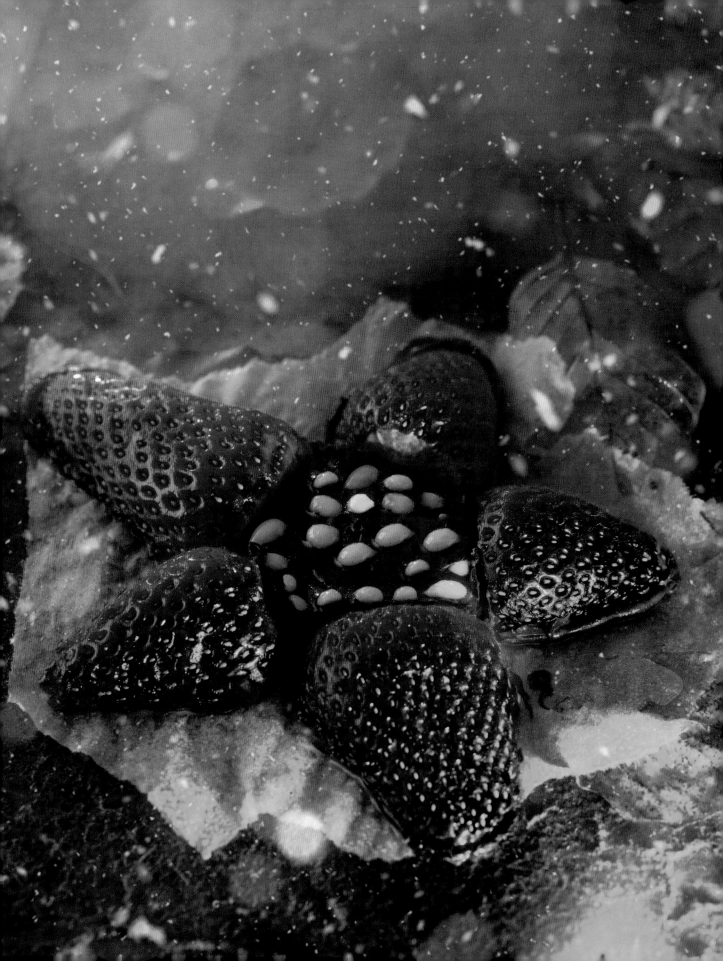

# Strawberry
# DEMOGORGON

Strawberries can be made to look a lot like a Demogorgon head. All you need is some dark chocolate to hold them together and some white chocolate teeth!

## INGREDIENTS

MAKES 8–10

* 1 lb 2 oz (500 g) strawberries (preferably elongated)

* 10½ oz (300 g) dark chocolate couverture

* 1⅔ cups (7 oz/200 g) confectioners' sugar

* 5–6 tbsp milk

## METHOD

Wash, pat dry, and halve the strawberries lengthwise.

Break or chop the chocolate into small pieces and melt in a bowl over a bain-marie or in the microwave for a few seconds, taking care that it doesn't overheat. Set aside and let cool slightly.

In the meantime, make a frosting by combining the sugar and milk in a bowl and mixing gently until the sugar is dissolved. The mixture should be thick, but still runny.

Place a sheet of parchment paper on the work surface. Arrange 5 strawberry halves to form a five-petal flower, leaving a round space with a diameter of about 1 inch (2.5 cm) in the middle.

One by one, dip the cut side of the strawberry halves into the melted chocolate and return them to their position in the flower. Fill the central space with 1 tablespoon of chocolate and gently press the strawberry petals against it so that they will be fixed in place by the chocolate as it sets.

Fill a freezer bag with the frosting and twist to close. Cut a small piece off one corner with kitchen scissors and use to pipe teeth over the chocolate. Let dry for a few minutes before serving.

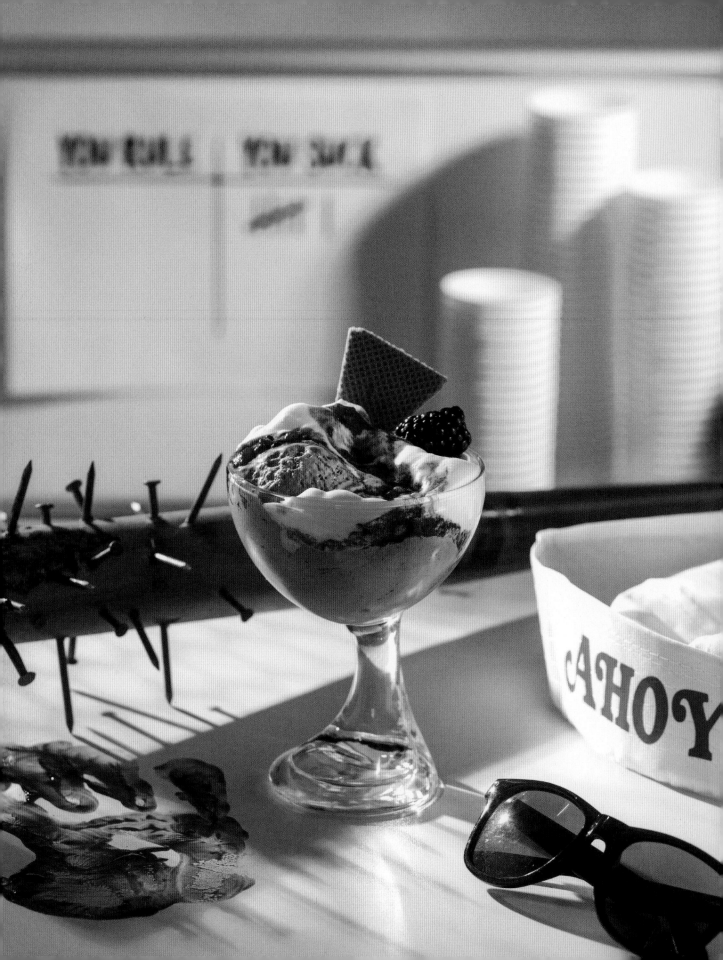

# Ahoy
# SURPRISE

Since Scoops Ahoy is no longer around to provide the residents
of Hawkins with ice cream treats, they've had to find another way
of getting their iced delights. The result is a simple yet refined
dessert that makes every ice cream lover's heart race.

## INGREDIENTS

SERVES 4

For the whipped cream
* Scant 1 cup (7 oz/200 g) whipping cream, chilled
* 2 tsp vanilla sugar
* 1½ tbsp (20 g) sugar

For the berry sauce
* 2¾ cups (12½ oz/ 350 g) assorted fresh berries
* 2 tsp vanilla sugar

For the raspberry ice cream
* 1 cup (8¾ oz/250 g) frozen raspberries
* ¼ cup (1¾ oz/50 g) sugar
* Scant 1 cup (7 oz/200 g) light cream

Extras
* 4 wafers, for decoration

## METHOD

For the whipped cream, whip the cream together with the vanilla sugar and sugar with a hand mixer in a mixing bowl until stiff peaks form.

Set aside some of the fresh berries for the garnish. For the sauce, use an immersion blender to finely puree the remaining berries together with the vanilla sugar.

For the ice cream, combine the frozen raspberries, sugar, and cream in a high-sided mixing bowl and blend finely with an immersion blender until smooth and creamy. Alternatively, use a blender.

Divide the ice cream evenly into four dessert bowls and top with whipped cream. Drizzle with berry sauce. Decorate each bowl with a wafer and remaining berries and serve immediately.

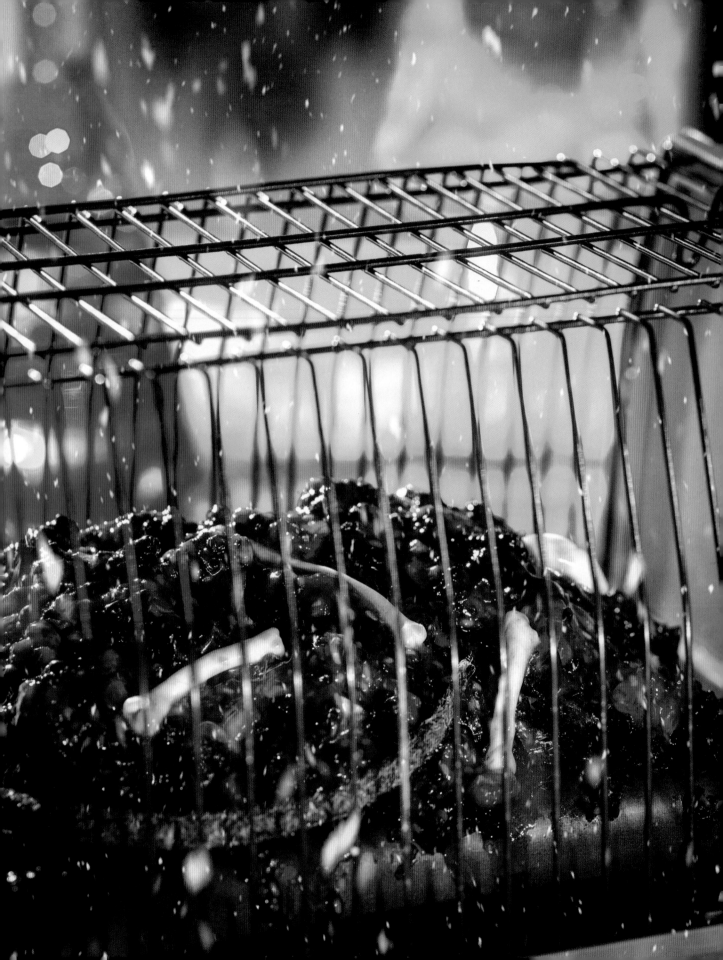

# Exploded RAT

Even rats are not what they seem in Hawkins. At your next party, shock and delight your friends at the same time with a different kind of fruity dessert. They might also burst with pleasure!

## INGREDIENTS

SERVES 6–8

* 34 chewy candies
* 1⅔ cups (7 oz/200 g) fresh raspberries
* 1⅓ cups (7 oz/200 g) fresh blackberries
* 10 sheets gelatin
* 3⅓ cups (1⅓ pints/ 800 ml) black currant juice
* ⅓ cup (2 oz/60 g) sugar
* 2 tsp vanilla sugar

## METHOD

Shape the chewy candies with your hands to make small bones. To do this, roll them into small sticks, leaving the ends slightly thicker. Use the back of a knife to carve notches into the ends of each bone, making them as life-like as possible.

Wash half of the berries and roughly mash and mix with a fork in a small bowl. Set aside the remainder.

Soften the gelatin in cold water according to the instruction on the package. Heat the black currant juice and sugar in a saucepan over medium heat. Do not let boil. Squeeze the gelatin sheets, add to the pan, and stir to dissolve. Add the crushed berries and stir briefly to combine. Then pour the mixture into a bowl, previously rinsed with cold water, and refrigerate for at least 6 hours.

Wash the remaining berries, roughly mash and mix with a fork in a small bowl, and mix with the vanilla sugar.

Roughly break up the set gelatin with two forks, place on serving plates, and decorate with the crushed berries. Finally, arrange small chewy candy bones on top.

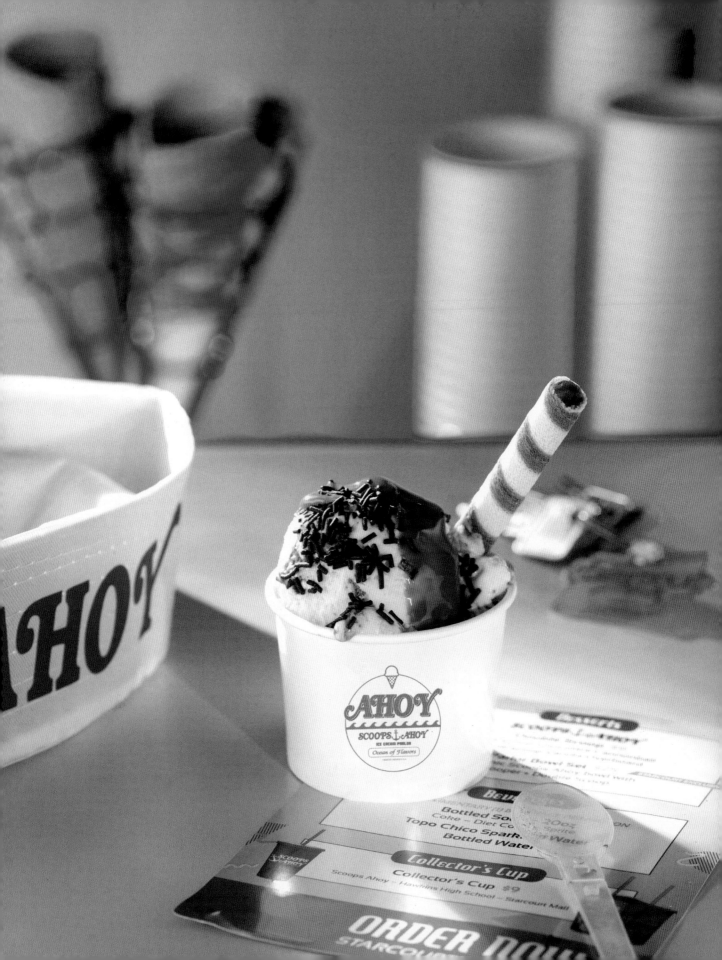

# Vanilla and Caramel
# ICE CREAM

Even though Scoops Ahoy is now buried under the rubble of Starcourt Mall, their delicious creations will be remembered by the town's residents for a long time to come. Enjoy a timeless classic from the most famous ice cream parlor Hawkins ever had.

## INGREDIENTS

SERVES 4

For the caramel sauce
- 7 tbsp/scant ½ cup (3½ oz/100 g) unsalted butter
- 1 cup (7 oz/200 g) sugar
- Salt
- ⅔ cup (6 oz/165 g) light cream

For the vanilla ice cream
- 1 vanilla bean
- 3 medium egg yolks
- Scant ¾ cup (5 oz/140 g) sugar
- 2 tsp vanilla sugar
- Scant 1 cup (7 fl oz/ 200 ml) milk
- Generous 1 cup (8¾ oz/ 250 g) whipping cream
- Chocolate sprinkles, for decoration
- Wafers, for decoration

Extras
- Ice cream maker

## METHOD

For the caramel sauce, cut the butter into small cubes. Melt the sugar in a large nonstick skillet over medium heat. During this process, do not stir. After a few minutes, when the sugar has turned into a golden brown caramel, add the butter cubes and then stir until creamy. Add a pinch of salt and incorporate. Put the cream into a mug, heat slightly in the microwave, and add to the pan. Gently stir to combine well and simmer over low heat for 2 minutes. Then transfer the caramel sauce to an airtight glass jar and refrigerate until ready to use.

For the vanilla ice cream, set up the ice cream maker according to the instructions for the appliance.

Split the vanilla bean lengthwise and scoop out the seeds with a spoon. Use a hand mixer to beat the egg yolks with the sugar for several minutes until thick and fluffy. Incorporate the vanilla seeds and vanilla sugar. Put the milk and vanilla bean into a small saucepan and bring to a simmer over low heat.

Remove the vanilla bean and gradually pour the milk into the egg mixture while stirring constantly.

Transfer the mixture to a saucepan over low heat and stir constantly until it thickens. Remove from the heat and let cool completely. In the meantime, whip the cream until stiff and fold into the cooled custard until smooth. Transfer to the ice cream maker and churn according to instructions for the appliance.

Serve the finished ice cream in bowls and drizzle liberally with caramel sauce. Decorate with chocolate sprinkles and wafers and serve immediately.

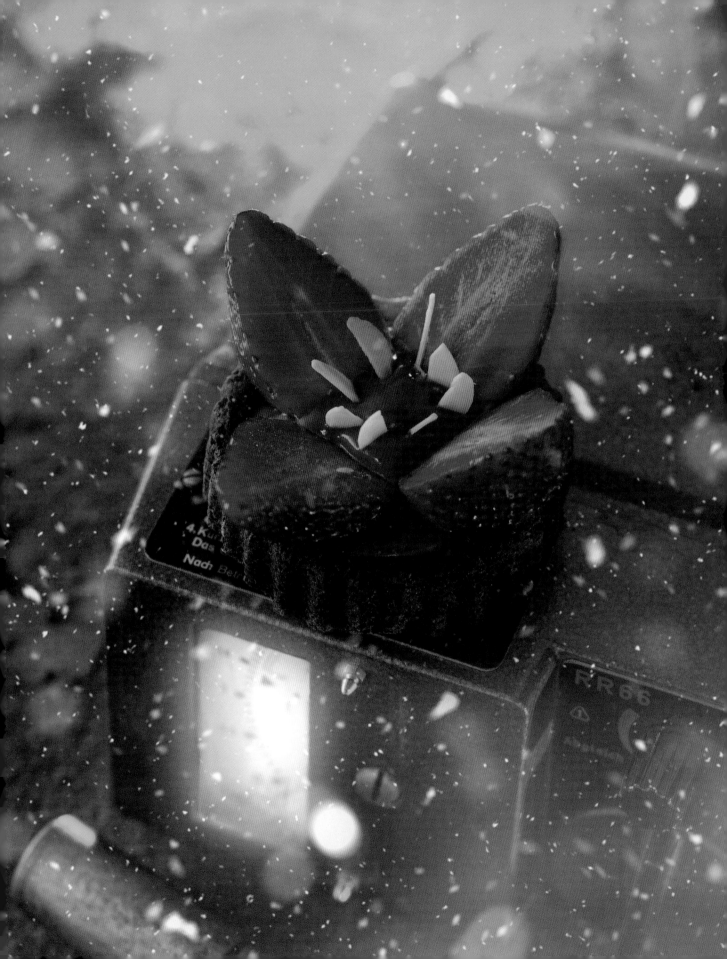

# *Demogorgon*
# TARTLETS

One of the most frightening things about the Demogorgon is that its entire face opens up like a hideous flower. Sweet chocolate is turned into a sickening, tooth-filled mouth poised to take a bite out of you.

## INGREDIENTS

MAKES 8

For the pastry

- ★ 1⅓ cups (6 oz/165 g) pastry flour
- ★ Generous ⅓ cup (1¼ oz/35 g) cocoa powder, plus more for dusting
- ★ 7 tbsp/scant ½ cup (3½ oz/100 g) cold unsalted butter, plus more for greasing
- ★ ⅓ cup (1½ oz/40 g) confectioners' sugar
- ★ 1 medium egg

For the chocolate ganache

- ★ 8¾ oz (250 g) dark chocolate
- ★ Generous 1 cup (8¾ oz/250 g) light cream

For decoration

- ★ 16–20 fresh strawberries
- ★ Slivered almonds

Extras

- ★ 8 tartlet molds
- ★ 1 circular cookie cutter (diameter slightly larger than that of the molds)

## METHOD

For the pastry, combine the flour, cocoa, butter, powdered sugar, egg, and 1 tablespoon cold water in a bowl and knead to a smooth dough. Shape the pastry into a flat brick, cover with plastic wrap, and rest for 1 hour in the refrigerator.

In the meantime, preheat the oven to 350°F. Grease the tartlet molds with butter and dust with cocoa powder.

Thinly roll out the cold pastry on a lightly floured work surface. Use the cookie cutter to cut out 8 pastry disks. Line the molds with the pastry, carefully pressing, and trim off the excess with a knife. Prick the pastry crusts several times with a fork to prevent from rising as they bake.

Bake in the oven (middle rack) for 15 minutes. Take the pastry crusts out of the oven and let cool completely inside the molds. Then carefully unmold.

For the chocolate ganache, roughly chop the dark chocolate and place in a bowl. In a small saucepan over medium heat, bring the cream to a boil and pour over the dark chocolate. Let stand for 3 minutes. Stir until the chocolate is completely melted and then let cool for a few minutes.

Pour the cooled chocolate ganache evenly into the tartlet crusts and smooth the surface. Wash, hull, and halve the strawberries. Arrange 4–5 halves in the ganache of each tartlet to resemble the Demogorgon's gaping mouth. Decorate the center with almond slivers.

Refrigerate the tartlets for at least 1 hour before serving to set the ganache.

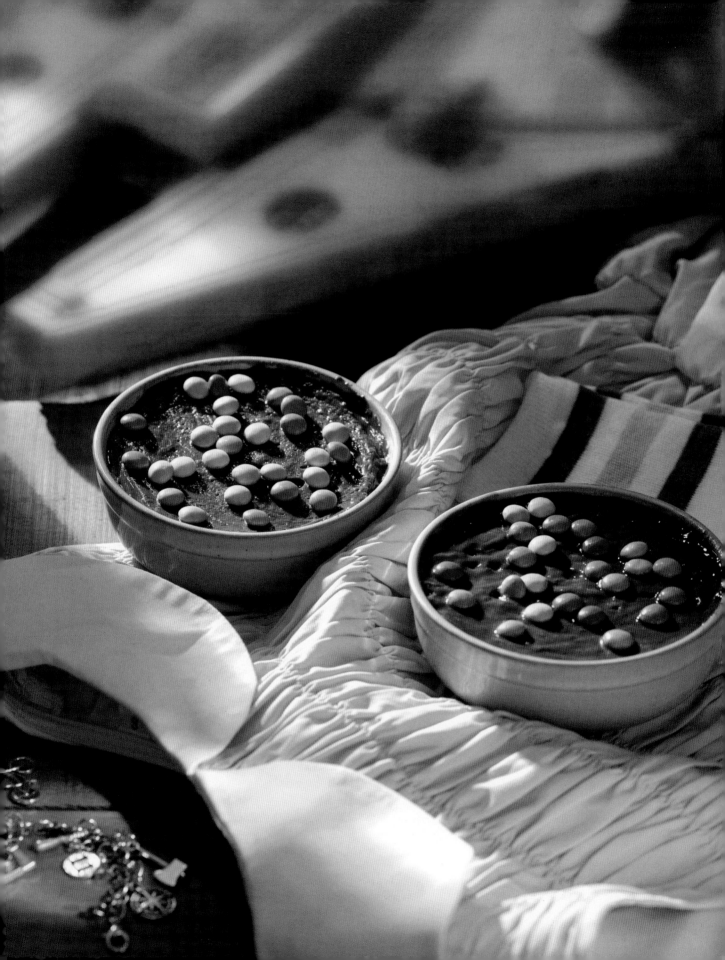

# CHOCOLATE PUDDING
## *with chocolate candies*

Chocolate pudding is a versatile dish with countless possibilities for toppings and additional flavors that you can try.

## INGREDIENTS

SERVES 2–3

* ★ 5¼ oz (150 g) milk chocolate
* ★ 1¼ cups (300 ml) milk
* ★ Scant 1 cup (7 oz/200 g) light cream
* ★ 1 tbsp cocoa powder
* ★ 1 tbsp sugar
* ★ ¼ cup (1 oz/30 g) cornstarch
* ★ 1 medium egg yolk
* ★ Salt
* ★ Chocolate candies in different colors

## METHOD

Combine the chocolate with scant 1 cup (7 fl oz/200 ml) milk and scant ½ cup (3½ fl oz/100 ml) cream in a saucepan over low heat, stirring constantly until the chocolate melts and is incorporated.

In a bowl, whisk the remaining milk and cream with the cocoa, sugar, cornstarch, egg yolk, and a pinch of salt. Whisk this mixture into the chocolate milk and simmer for 3–4 minutes, stirring constantly, or until the pudding visibly thickens.

Serve the pudding in a large bowl or several small ones, decorate with the chocolate candies, and enjoy warm or cold.

# SWEETS

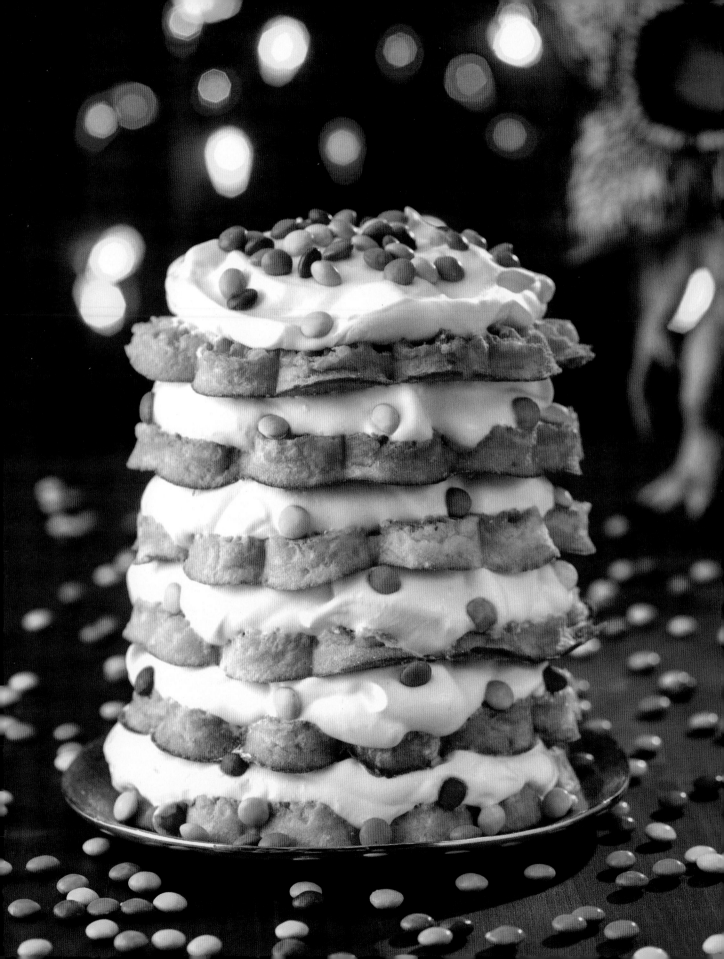

# HOPPER'S WAFFLE
## *Extravaganza*

No one knows how much Eleven loves waffles more than Chief Hopper. He always whips up his Triple-Decker Waffle Extravaganza whenever there's trouble at home with Eleven to put right.

## INGREDIENTS

SERVES 1

- ★ 2 sticks/1 cup (4 oz/ 125 g) unsalted butter, softened
- ★ ⅓ cup (2½ oz/75 g) sugar
- ★ 2 tsp vanilla sugar
- ★ Salt
- ★ 3 medium eggs
- ★ 2 cups (8¾ oz/250 g) pastry flour
- ★ 2 tsp baking powder
- ★ Scant 1 cup (7 fl oz/ 200 ml) milk
- ★ Oil, for greasing
- ★ 2 cups (1 lb 2 oz/500 g) whipping cream, chilled
- ★ Generous ¼ cup (1¼ oz/35 g) confectioners' sugar
- ★ Chocolate candies in different colors, to decorate

Extras
- ★ Waffle maker

## METHOD

For the batter, cream the butter with the sugar, vanilla sugar, and a pinch of salt in a bowl with a hand mixer. Add the eggs one at a time and incorporate well. Mix the flour with the baking powder and stir into the mixture, alternating with the milk, to make a creamy and frothy batter that is not too thick.

Turn on the waffle maker and grease by brushing with oil. Put 2–3 tablespoons of batter per waffle in the middle of the waffle maker and cook until golden brown. Let the finished waffles cool individually on a cake rack. Do not stack them, otherwise they will quickly become greasy!

In the meantime, make a Chantilly cream. To do this, pour the cream into a large mixing bowl, sift in the confectioners' sugar, and whisk with a hand mixer until it begins to stiffen. Gradually increase the speed. Whip the cream until it is as compact as possible and light peaks form at the edges.

Assemble as follows: First, place a waffle on a plate. Cover with a layer of whipped cream and chocolate candies. Cover with the next waffle and repeat the process until all the waffles are used up. Top with remaining whipped cream, sprinkle liberally with chocolate candies, and enjoy immediately.

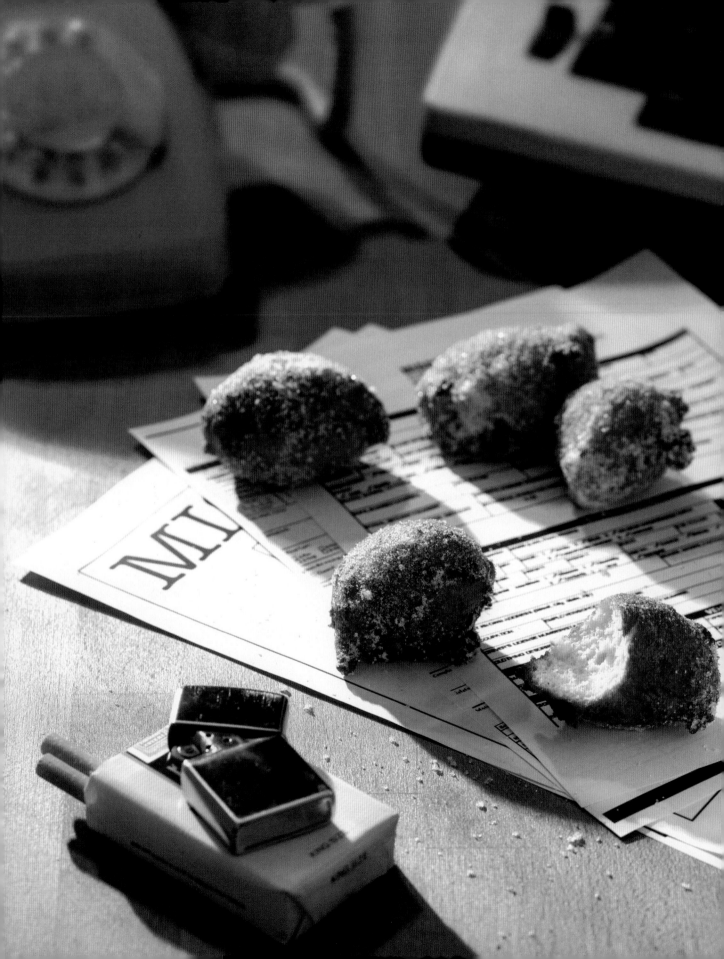

# Quark
# FRITTERS

Like doughnuts and coffee, quark fritters are often enjoyed as sweet one-bite snacks at the Hawkins Police Station. Because quark is packed with protein and calcium, it is the one snack that Flo doesn't replace with apples when Hopper is around.

## INGREDIENTS

MAKES ABOUT 20

- ★ ⅔ cup (3½ oz/100 g) raisins
- ★ Scant 1 cup (7 fl oz/200 ml) orange juice
- ★ 2½ cups (10½ oz/ 300 g) pastry flour
- ★ 1 tbsp baking powder
- ★ 3 medium eggs
- ★ ⅔ cup (4½ oz/125 g) sugar
- ★ 2 tsp vanilla sugar
- ★ Scant 1 cup (8¾ oz/250 g) quark
- ★ Salt
- ★ Zest of ½ organic lemon
- ★ Oil, for deep-frying
- ★ Sugar, for dredging

## METHOD

In a bowl, soak the raisins in the orange juice for 1 hour. Drain well in a strainer.

Mix the flour with the baking powder in a separate bowl.

Beat the eggs with the sugar and vanilla sugar in a mixing bowl until thick and fluffy. Then add the flour mixture, quark, a pinch of salt, and the lemon zest, and incorporate well. Fold the raisins into the batter. The batter should be thick. If it is too runny, add a little more flour.

Heat the oil in a large pot to 350°F (180°C). Use two tablespoons to shape the batter into oval-shaped quenelles, and fry in the hot oil, turning occasionally, until golden brown (3–4 minutes in total). Make sure not to overcrowd the pot. Carefully remove the finished fritters with a slotted spoon and drain the excess oil on paper towels.

Put the sugar onto a flat plate and dredge the drained fritters well. Serve immediately.

# Demogorgon CAKE

How many guests will dare try this different kind of cake? You can even use the excess cake pieces to make cake pop versions of the Demogorgon larvae for an extra terrifying thrill!

## INGREDIENTS

MAKES 1

For the sponge cake
* 6 medium eggs
* Generous ¾ cup (5½ oz/160 g) sugar
* Salt
* 1 tsp vanilla extract
* Generous 1⅓ cups (6 oz/170 g) pastry flour

For the cream cheese frosting
* Generous 2 cups (1 lb 2 oz/500 g) quark
* Scant 1 cup (7 oz/200 g) cream cheese
* 1⅔ cups (14 oz/400 g) light cream
* 5 (¼-oz/8-g) envelopes (Dr. Oetker's Whip it) whipped cream stabilizer

For the fruit glaze
* 1½ cups (7 oz/200 g) blackberries
* 1¼ cups (10 fl oz/300 ml) blackberry juice (or raspberry juice)
* 3¾ tsp (⅜ oz/10 g) agar powder (or gelatin)

## METHOD

Combine the eggs, sugar, a pinch of salt, and vanilla extract in a bowl and beat with a hand mixer for 10–15 minutes until thick and fluffy. Then sift the flour into the bowl and gently fold in. Do not stir!

Preheat the oven to 350°F. Grease the springform pan with cooking spray.

Pour the batter evenly into the pan and bake for 25–30 minutes, until the cake is golden brown. Take the cake out of the oven and carefully run a knife between the side band and bottom of the pan. Then remove the side band pan and let the cake cool on a rack.

In a bowl, gently mix the quark with the cream cheese. In a separate bowl, whisk the cream with the stabilizer, fold into the cream cheese mixture, and refrigerate.

Combine the blackberries, blackberry juice, and agar in a small saucepan and briefly bring to a boil over medium heat. Remove from heat and let the mixture cool a little without setting.

Use a large, sharp knife to cut the cake in half across the center. Mix 4 tablespoons of the cream cheese frosting with 3 tablespoons of the fruit glaze in a small bowl. Spread the mixture in an even layer over the bottom half of the cake and cover with the top half. Use a toothpick or a knife to make the outline of a five-petal flower on the cake. With a large, sharp knife, cut through the cake along the lines to give it the desired shape.

Put some of the frosting into a pastry bag. Use the remaining frosting to cover the sides of the cake. Pipe frosting along the top edge of the cake and a circle in the center of the cake. Insert almond slivers crookedly into the cream.

Use a spoon to spread the fruit glaze evenly over the top of the cake between the lines of frosting and then refrigerate for 10 minutes to set. Once the cake has cooled, arrange the remaining almond slivers over the top and press in lightly.

### For the marshmallow threads

★ 16 (3½ oz/100 g) marshmallows

★ 1 tbsp unsalted butter

### Extras

★ Springform pan (10¼ inches/26 cm in diameter)

★ Nonstick cooking spray

★ ⅔ cup (3½ oz/100 g) blanched almonds

Combine the marshmallows and butter in a small bowl and heat in the microwave for 10–15 seconds. Remove and whisk briskly until the butter is completely dissolved. With care, take a small amount of the marshmallow mixture in your hands, pull long strings with your fingers, and spread them messily over the cake. When the mixture becomes too firm to pull, heat again briefly in the microwave.

## STRANGER
### TIP

Use excess cake pieces to make cake pops.

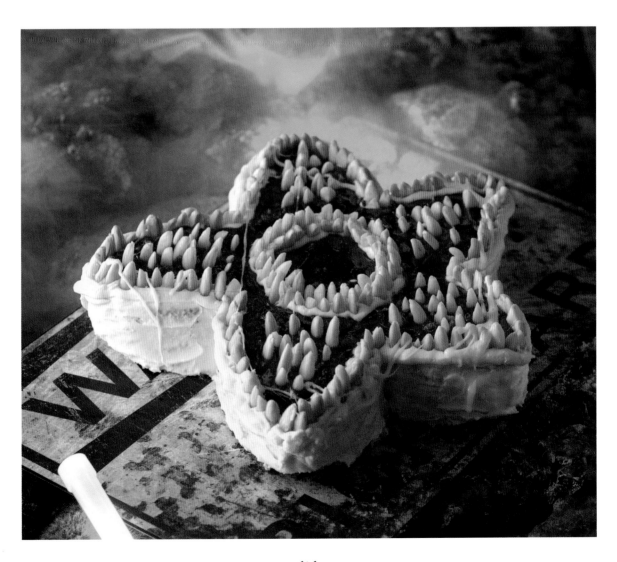

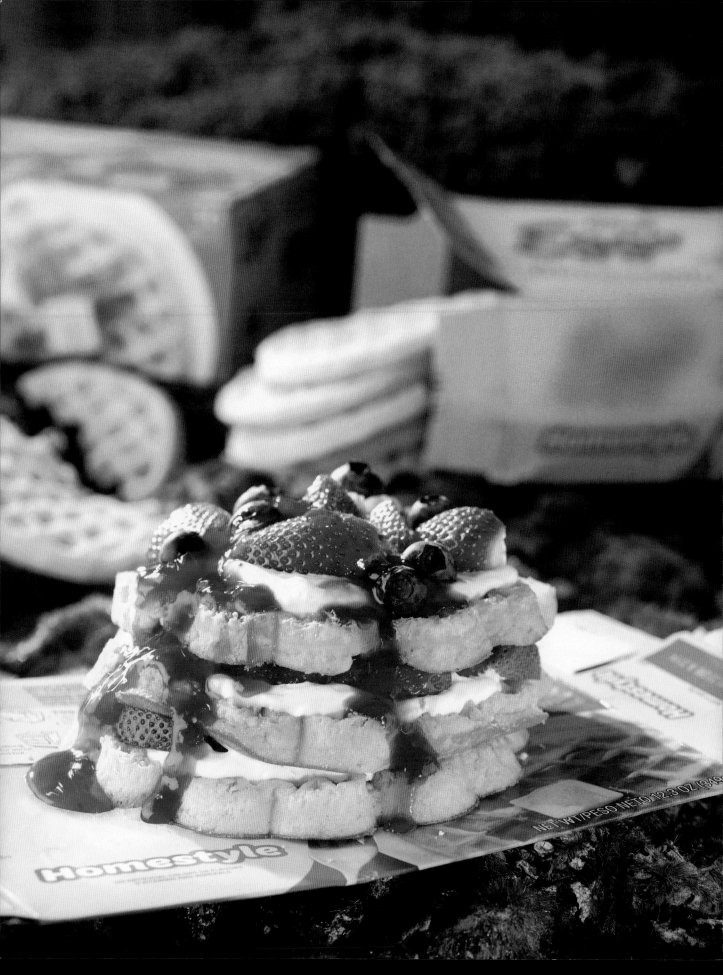

# Strawberry Shortcake
# WAFFLES

Although Eleven loves plain waffles, this recipe turns a regular treat into a succulent dessert for two! Make this for a romantic evening in or even as a birthday cake for the waffle-lover in your life.

## INGREDIENTS

MAKES 2

For the waffles

* 1 stick/½ cup (4 oz/125 g) unsalted butter
* ½ cup (3½ oz/100 g) sugar
* 4 medium eggs
* 1 tsp vanilla extract
* 2 cups (8¾ oz/250 g) pastry flour
* 1½ tsp baking powder
* Generous 1 cup (8¾ fl oz/250 ml) buttermilk
* Oil, for greasing

For the topping

* Scant ½ cup (100 g) whipping cream
* 1 cup (8¾ oz/250 g) mascarpone cheese
* ⅔ cup (5 fl oz/150 ml) vanilla yogurt
* 2 tsp vanilla sugar
* ¼ cup (1 oz/30 g) confectioners' sugar
* Juice and zest of 1 small organic lemon
* 8¾ oz (350 g) fresh strawberries
* Generous 1 cup (5¼ oz/150 g) assorted fresh berries
* Strawberry sauce (ready-made product)

Extras

* Waffle maker

## METHOD

In a mixing bowl, cream the butter and sugar together with a hand mixer until thick. Gradually add the eggs while continuing to beat and incorporate vanilla extract.

Combine the flour and baking powder in a small bowl and add to the butter mixture. Next, slowly add the buttermilk in a thin stream while continuing to beat.

Turn on the waffle maker and grease by brushing with oil. Put 2–3 tablespoons of batter per waffle in the middle of the waffle maker and cook until golden brown. Let the finished waffles cool individually on a cake rack. Do not stack them; otherwise they will quickly become greasy!

For the topping, whip the cream until stiff peaks form. In a bowl, carefully combine the mascarpone, vanilla yogurt, vanilla sugar, and confectioners' sugar. Add the lemon juice and zest and fold in together with the whipped cream.

Place a waffle on a flat plate and cover with a layer of mascarpone cream. Wash the berries and spread them evenly over the cream. Cover with another waffle and repeat the process with the mascarpone cream and berries. Cover with a third waffle, top with cream and berries, and drizzle with strawberry sauce. Do the same with the remaining waffles and toppings. Enjoy immediately.

# Peanut
# BAR

Given their particularly high content in protein and dietary fiber, nut and muesli bars are considered a fast and easy supply of energy. What's more, this homemade version does away with unnecessary sugar and chocolate. Create your own mix of nuts, seeds, cereal, and fruit for a healthy snack to have on the go.

## INGREDIENTS

MAKES 25–30

* 1 cup (7 oz/200 g) sugar
* Generous ¼ cup (3½ oz/ 100 g) honey
* 3½ cups (1 lb 2 oz/ 500 g) raw peanuts, shelled

## METHOD

Line a baking sheet with parchment paper. Keep another sheet of parchment paper on hand for later.

Combine the sugar and honey in a nonstick skillet. Place over medium heat and cook gently, stirring constantly, until caramelized and golden brown. This may take a few minutes.

Remove the pan from the heat and quickly stir in the peanuts.

Spread the mixture evenly on the prepared baking sheet, smooth the surface, and cover with the second sheet of parchment paper. Roll out flat with a rolling pin, let dry for a few minutes, and then carefully remove the top sheet.

Transfer to a cutting board and cut into bars of the desired size with a large, sharp, and lightly greased knife. Store the bars in an airtight container, separating the layers with parchment paper to keep them from sticking together.

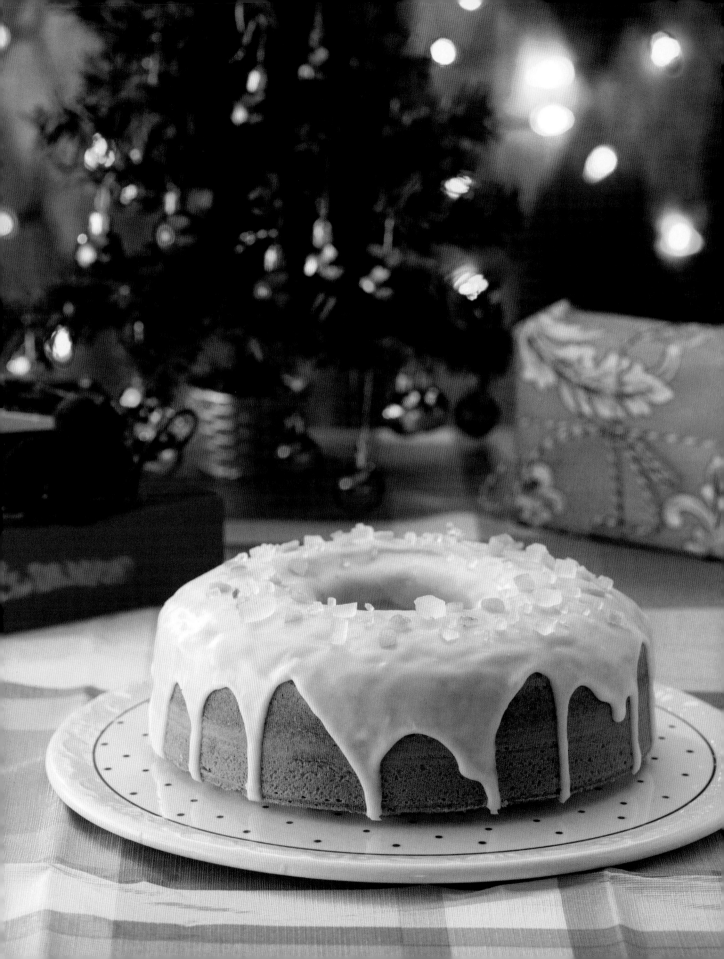

# Mrs. Wheeler's
# CHRISTMAS CAKE

Only the best is good enough for Mrs. Wheeler's family and friends, which is why only carefully selected recipes find their way into Karen's kitchen. Try this moist cake for yourself, and you'll understand why Christmas is a special holiday in the Wheeler home.

## INGREDIENTS

MAKES 1

For the cake

* Unsalted butter, for greasing
* 1 cup (4½ oz/125 g) pastry flour, plus more for dusting
* 5 medium eggs
* 2 cups (8¾ oz/250 g) confectioners' sugar
* 4 tsp vanilla sugar
* Generous 1 cup (8¾ oz/ 250 ml) oil
* Generous 1 cup (8¾ oz/ 250 ml) egg liqueur
* 1 cup (4½ oz/125 g) cornstarch
* 1 tbsp baking powder

For decoration

* Generous 2⅓ cups (10½ oz/300 g) confectioners' sugar
* Candied fruit

Extras

* Baking pan (11 inches/ 28 cm in diameter)

## METHOD

Preheat the oven to 350°F. Grease a baking pan with butter and dust with flour.

In a bowl, beat the eggs, confectioners' sugar, and vanilla sugar with a hand mixer until thick and fluffy. Then, adding in a thin stream, incorporate the oil, followed by the egg liqueur.

In a separate bowl, thoroughly combine the flour, cornstarch, and baking powder and then add the dry ingredients to the beaten egg mixture. Fold to incorporate. Pour the batter evenly into the greased baking pan.

Bake the cake in the oven, about 60 minutes. (Insert a toothpick to test; if it comes out clean, the cake is done.) Take the cake out of the oven and let cool for a few minutes without unmolding.

Make the frosting by mixing the confectioners' sugar with 4 tablespoons of water in a small bowl.

Turn the cooled cake out of the pan and cover liberally with frosting. Let dry briefly, and then decorate with the candied fruit.

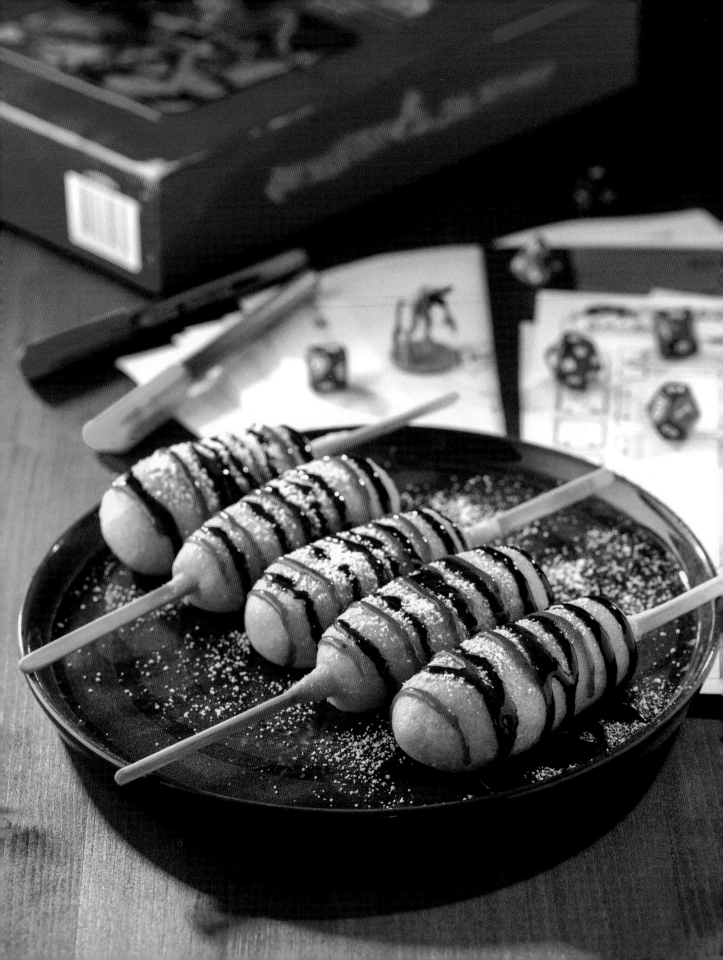

# Deep-Fried
# TWINKIES

These cream-filled snack cakes were must-haves at the Roane County Fun Fair. You can modify the basic recipe to suit your taste and can even use this cooking method to create other classic county fair treats, like deep-fried candy bars, bananas, and pickles.

## INGREDIENTS

MAKES 6

* ★ 6 Twinkies or other cream-filled cake snacks
* ★ Generous 1 cup (8¾ fl oz/250 ml) milk
* ★ 2 tbsp vinegar
* ★ 1 tbsp neutral oil
* ★ 1 cup (4½ oz/125 g) pastry flour, plus more for dredging
* ★ 1 tbsp baking powder
* ★ Salt
* ★ Vegetable oil, for deep-frying
* ★ Confectioners' sugar for garnish (as needed)
* ★ Strawberry sauce (ready-made product, as needed), for decoration
* ★ Chocolate sauce (ready-made product, as needed), for decoration

Extras

* ★ 6 wooden skewers

## METHOD

Freeze the cakes for 4–5 hours or overnight.

In a small bowl, mix the milk with vinegar and oil.

In another bowl, mix the flour, baking powder, and ½ tablespoon salt. Then add the wet ingredients to the dry ingredients and incorporate to make a smooth batter. Chill the batter in the refrigerator until the frying oil is hot enough.

Heat the vegetable oil in the deep-fryer to 375°F (190°C) according to the instructions for the appliance (alternatively, use a large pot). To test, dip the handle of a wooden spoon into the oil. If small bubbles rise, it is hot enough to use.

Gently insert a wooden skewer lengthwise into each cake, leaving about 7–8 cm to use as a handle. Dredge in the flour, covering completely, and then plunge upside down in the chilled batter. Turn the cake inside the batter until it is completely covered. Drain the excess and carefully submerge in the hot frying oil. You should only fry 2 or 3 cakes at a time so that the pot or fryer is not overcrowded. As the cakes will float to the top, press down on them with a heat-resistant metal utensil to ensure even coloring. Fry for about 3–4 minutes, until golden brown.

Transfer the deep-fried Twinkies to a plate lined with paper towels and rest for 5 minutes. To serve, dust with confectioners' sugar and drizzle with strawberry sauce and chocolate sauce as desired.

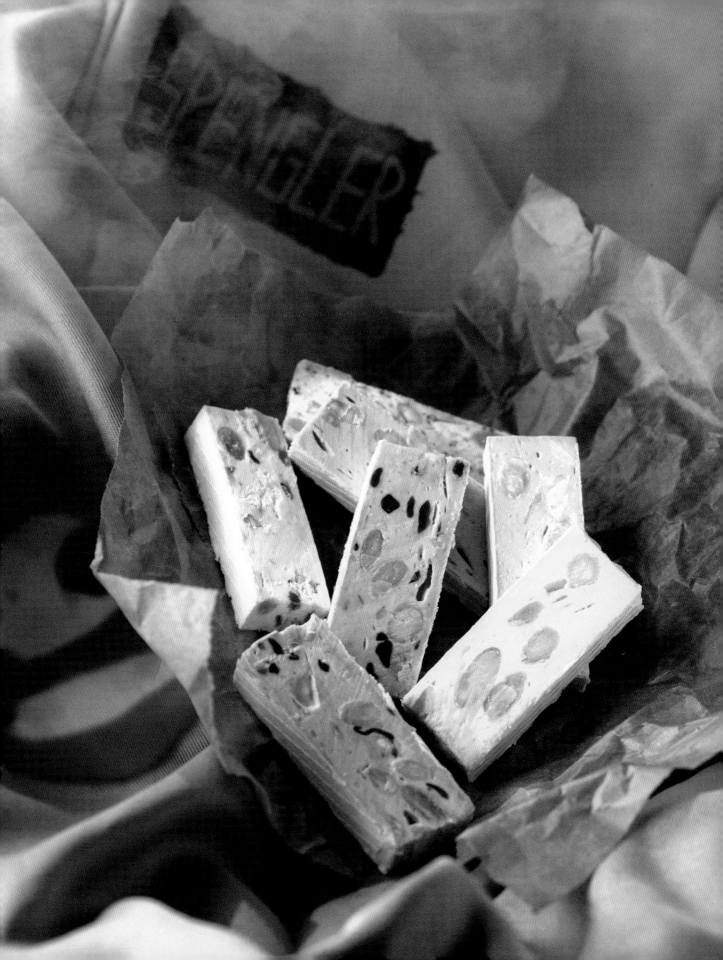

# D'Artagnan's
# FAVORITE NOUGAT

Even interdimensional Demodogs love this tasty treat. Nougat—top three for Dustin—isn't just to be enjoyed at Halloween. This sweet treat is particularly good for enhancing cakes and desserts and as an accompaniment for hot beverages.

## INGREDIENTS

MAKES 25

* 1¾ cups (8¾ oz/250g) blanched almonds
* 1 cup (7 oz/200g) sugar
* ¾ cup (8¾ oz/250 g) honey
* 3½ tbsp (1½ oz/40 g) glucose syrup
* Food coloring (optional)
* 2 medium egg whites
* Salt
* Large square edible wafer paper sheets

Extras
* Sugar thermometer
* Small ovenproof dish

## METHOD

Preheat the oven to 350°F. Line a baking sheet with parchment paper.

Spread the almonds evenly over the baking sheet and roast in the oven until golden brown, about 10 minutes. Take care not to burn the almonds. Then let the almonds cool on the baking sheet.

Make a light caramel by melting the sugar, honey, and glucose syrup in a small saucepan over medium heat, stirring constantly, until the temperature reaches 300°F (150°C) and the sugar has completely dissolved. If you want your nougat to be more colorful, stir in a few drops of food coloring at this point.

In a separate bowl, beat the egg whites with a pinch of salt until stiff peaks form and set aside.

Bring a pot of water to a boil as a bain-marie. Place the bowl with the beaten egg whites again over the bain-marie and whisk in the hot caramel mixture in a thin stream. Continue to stir until the mixture becomes firm (this may take a few minutes). Then fold in the toasted almonds.

Line the bottom of a small ovenproof dish with wafer paper, making sure there are no gaps, and cover evenly with the nougat mixture. Smooth the top with a spatula and add another layer of wafer paper. Cover with a wooden board or cutting board and add a weight to flatten the nougat.

Refrigerate the nougat overnight. Then turn it out onto a cutting board and cut into bars with a large, sharp knife. Store in an airtight container.

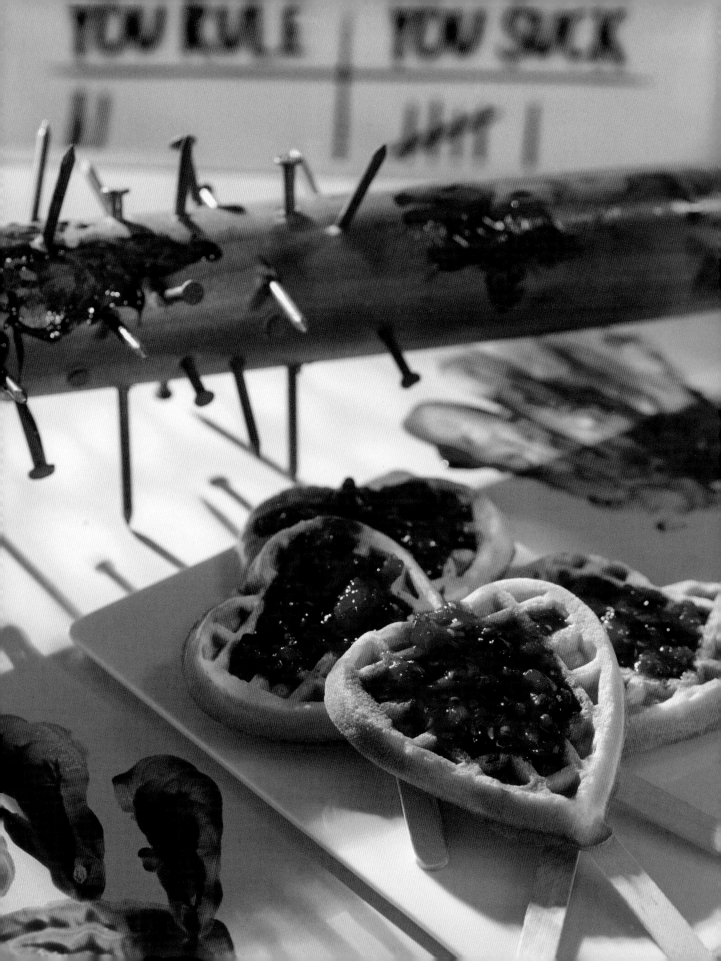

# WAFFLE
## *Pops*

Even if you aren't running away from a monster from another dimension, enjoy a sweet snack on the go with this easy recipe. You can even decorate your waffle on a stick in Halloween Horror Nights style with peanuts and sprinkles.

## INGREDIENTS

MAKES 10

- ★ 2¼ sticks/1 cup plus 2 tbsp (8¾ oz/250 g) unsalted butter, softened
- ★ 1 cup plus 2 tbsp (8 oz/ 230 g) sugar
- ★ 2 tsp vanilla sugar
- ★ Salt
- ★ 4 medium eggs
- ★ 4 cups (1 lb 2 oz/500 g) all-purpose flour
- ★ 1 tablespoon baking powder
- ★ Scant 1 cup (7 fl oz/200 ml) milk
- ★ ¾ cup (3½ oz/100 g) fresh raspberries
- ★ ⅔ cup (3½ oz/100 g) fresh blackberries

Extras
- ★ Waffle maker
- ★ Ice pop sticks

## METHOD

In a bowl, beat the butter, sugar, vanilla sugar, and a pinch of salt with a hand mixer until creamy. Stir in the eggs one at a time and then beat the mixture until thick and fluffy.

In a separate bowl, mix the flour and baking powder. Then add the dry mixture alternately with 1¼ cups (10 fl oz/300 ml) of water and the milk to the egg and sugar mixture, incorporating well to form a thick batter.

Heat and grease the waffle maker according to the instructions for the appliance and then position the sticks. Spoon a uniform amount of batter onto the waffle grids. Cook the waffles until golden brown and then transfer to a rack to cool.

In the meantime, combine the raspberries and blackberries in a small bowl and roughly mash with the back of a tablespoon. Spread over the cooled waffles as desired.

# Strawberry COOKIES

Crispy on the outside and soft on the inside, these cookies really make your heart race. Fuel your next campaign with your own Hellfire Club with these strawberry sweets!

## INGREDIENTS

MAKES 12

* ⅗ cup (3½ oz/100 g) roasted and lightly salted macadamia nuts
* 3½ oz (100 g) dark chocolate couverture
* 2 tbsp (⅜ oz/10 g) freeze-dried strawberries
* 1¼ sticks/ ⅔ cup (5¼ oz/ 150 g) unsalted butter, softened
* 1 tbsp vanilla extract
* Scant 1 cup (6½ oz/ 180 g) cane sugar
* 1 medium egg
* 1⅔ cups (7 oz/200 g) pastry flour
* 2 tsp baking powder

## METHOD

Roughly chop the nuts and the chocolate separately. Chop up the strawberries.

Combine the butter, vanilla extract, and sugar in a bowl and beat for 3 minutes with a hand mixer until creamy. Add the egg and quickly incorporate.

Mix the flour and baking powder in a separate bowl and sift over creamed butter mixture. Fold until combined.

Add the nuts, chocolate, and strawberries to the cookie dough and mix until evenly distributed.

Preheat the oven to 350°F. Line a baking sheet with parchment paper.

Use an ice cream scoop (or tablespoon) to place the dough on the baking sheet. Space the cookies well apart because they will spread a lot as they bake (it's best not to make more than 5–6 cookies per batch). Moisten your hands a little and gently flatten the mounds of dough.

Bake the cookies for 10–12 minutes. They should turn golden brown around the edges, but otherwise they should be lightly colored to keep the cookies as chewy as possible. Take the cookies out of the oven and let cool completely on the baking sheet to prevent from breaking.

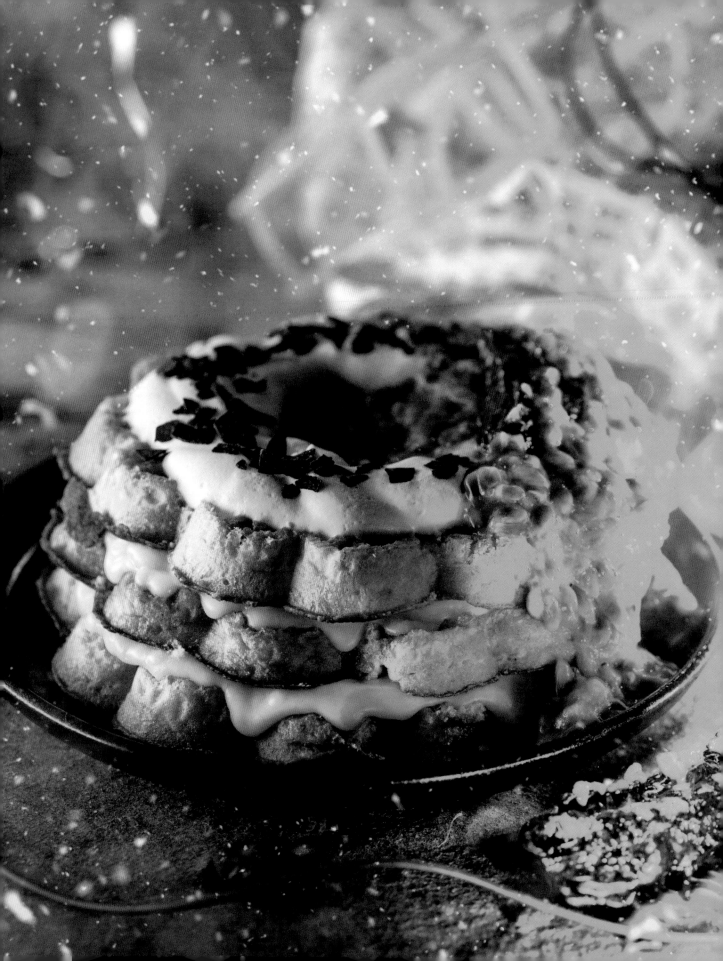

# *Stranger* WAFFLES

You can never have too many waffles; just ask Eleven. Here's an Upside-Down version of Eleven's favorite Triple Decker Waffle Extravaganza with a slimy, but sweet passion fruit and gummy worm topping.

## INGREDIENTS

MAKES 2

For the licorice worms
* 7 oz (200 g) licorice chewy candies
* ⅓ cup (1¾ oz/50 g) chopped pistachio nuts

For the waffles
* About 2 (8¾ oz/250 g) apples 7 tbsp/scant
* ½ cup (3½ oz/100 g) unsalted butter
* 2 tsp vanilla sugar
* ¼ cup (1¾ oz/50 g) cane sugar
* Salt
* 2 medium eggs
* 1⅔ cups (7 oz/200 g) all-purpose flour
* ½ tsp baking powder
* ⅔ cup (5 fl oz/150 ml) milk
* Oil, for greasing

For the topping
* 4 passion fruits
* 1¼ cups (10½ oz/300 g) whipping cream
* ¾ cup (7 oz/200 g) crème fraîche
* ⅓ cup (1¾ oz/50 g) confectioners' sugar
* 2 tsp vanilla sugar
* ½ tsp vanilla extract
* Chocolate shavings

## METHOD

For the licorice worms, chop up the candies and put them into a small saucepan with 3½ tablespoons (1¾ fl oz/50 ml) water. Place over low heat and slowly bring to a boil, stirring occasionally. Then continue to stir, adding water if necessary, until the licorice has completely dissolved (this may take a few minutes). Remove from the heat and let cool and then use your fingers to shape the licorice paste into worms. Decorate with pistachios and let dry completely.

For the waffles, wash, peel, and grate the apples.

Combine the butter, vanilla sugar, cane sugar, and a pinch of salt in a bowl and beat with a hand mixer until thick and fluffy. Gradually incorporate the eggs.

In a small bowl, combine the flour and baking powder and stir into the creamed butter mixture. Add the milk and gently incorporate. Fold in the grated apples into the batter.

Turn on the waffle maker and grease by brushing with oil. Put 2–3 tablespoons of batter per waffle in the middle of the waffle maker and cook until golden brown. Let the finished waffles cool individually on a cake rack. Do not stack them, otherwise they will quickly become greasy!

Cut the passion fruits open with a knife and scoop out the pulp into a small bowl. Roughly crush with a fork.

In a separate bowl, whip the cream until stiff peaks form. Combine the crème fraîche, confectioners' sugar, vanilla sugar, and vanilla extract in a bowl and fold in the whipped cream.

Place a waffle on the plate and cover with a layer of vanilla cream. Top with another waffle, spread with more cream, and finish with a third waffle. Spread another layer of vanilla cream, then decorate with chocolate shavings, the crushed passion fruit and licorice worms. Serve immediately.

Extras
* Waffle maker

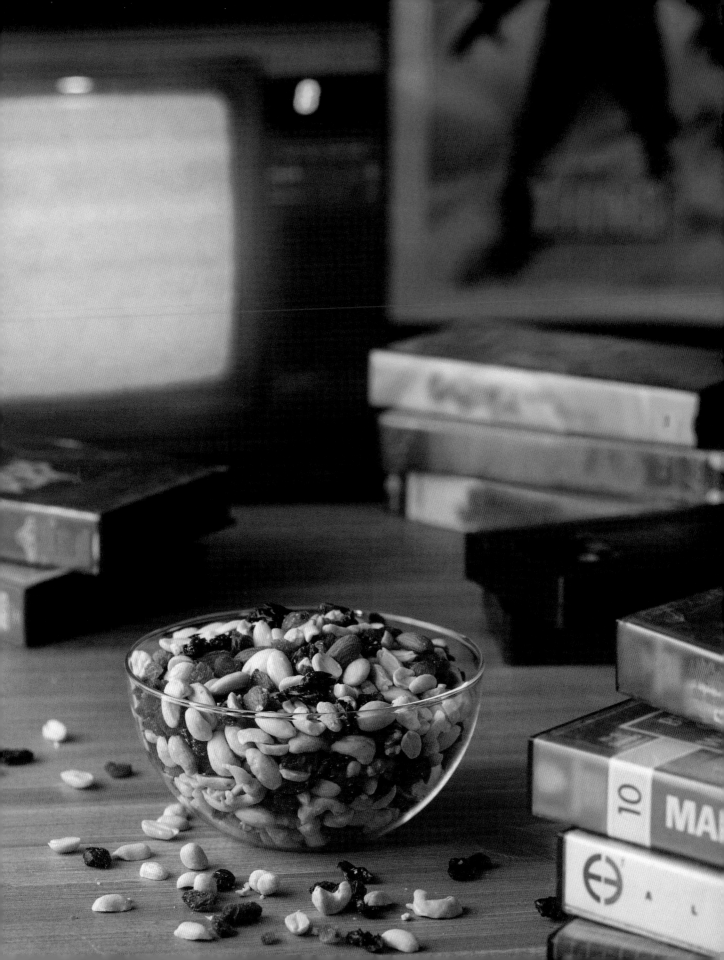

# Homemade
# TRAIL MIX

As Dustin says, "We need energy for our travels. For stamina." This trail mix is the perfect snack for evenings of series binge-watching.

## INGREDIENTS

MAKES APPROXIMATELY 2 CUPS

- ⅔ cup (3½ oz/100 g) dried cranberries
- ⅔ cup (3½ oz/100 g) raisins
- 1½ cups (7 oz/200 g) cashew nuts
- 1 cup (5¼ oz/150 g) almonds, shelled
- 2 cups (7 oz/200 g) pecans, shelled
- 1 cup (5¼ oz/150 g) raw peanuts, shelled
- ¾ cup (3½ oz/100 g) hazelnuts, shelled
- Ground cinnamon (as needed)
- Coarse sea salt (as needed)

## METHOD

Combine all the ingredients in a large, airtight container. Place the lid on the container and shake well to coat everything with the seasoning.

If you don't like one or more of the ingredients, or if you particularly love one of them, simply vary the trail mix composition to suit your taste.

This trail mix will keep for 3–4 weeks in an airtight container.

# Hellfire Two-Tone POPCORN

This treat will keep players of the Hellfire Club going throughout even the most grueling campaigns. Sit back and relax with this homemade snack while the Dungeon Master spins their tale!

## INGREDIENTS

SERVES 4–5

★ 4 tbsp cooking oil

★ ½ cup (3½ oz/100 g) popcorn kernels

★ 5¼ oz (150 g) white chocolate

★ 5¼ oz (150 g) ruby chocolate

★ Coarse sea salt

## METHOD

Put the oil and popcorn kernels into a pot large enough to cover the bottom with an even layer of kernels. Turn the stove on the highest heat setting and cover the pot with a lid. When the corn starts to pop, reduce the heat to low and wait until all the kernels have popped. This may take a few minutes. Divide the popcorn evenly between two large bowls.

Line two baking sheets with parchment paper.

Roughly chop both types of chocolate and melt in separate bowls over a bain-marie. Add a pinch of coarse sea salt to the white chocolate. Then, one bowl and color of chocolate at a time, pour the melted chocolate over the popcorn and mix thoroughly. Then spread each of the chocolate-coated popcorn mixtures on a separate baking sheet, spaced apart to prevent clumping, and let dry.

Store in an airtight container.

## STRANGER TIP

Ruby chocolate isn't simply milk chocolate or dark chocolate dyed pink, but a distinct variety of chocolate made from the ruby cocoa bean. That's why you should definitely try to use real ruby chocolate for this recipe. You can find it in well-stocked confectioneries or on the Internet, among other places.

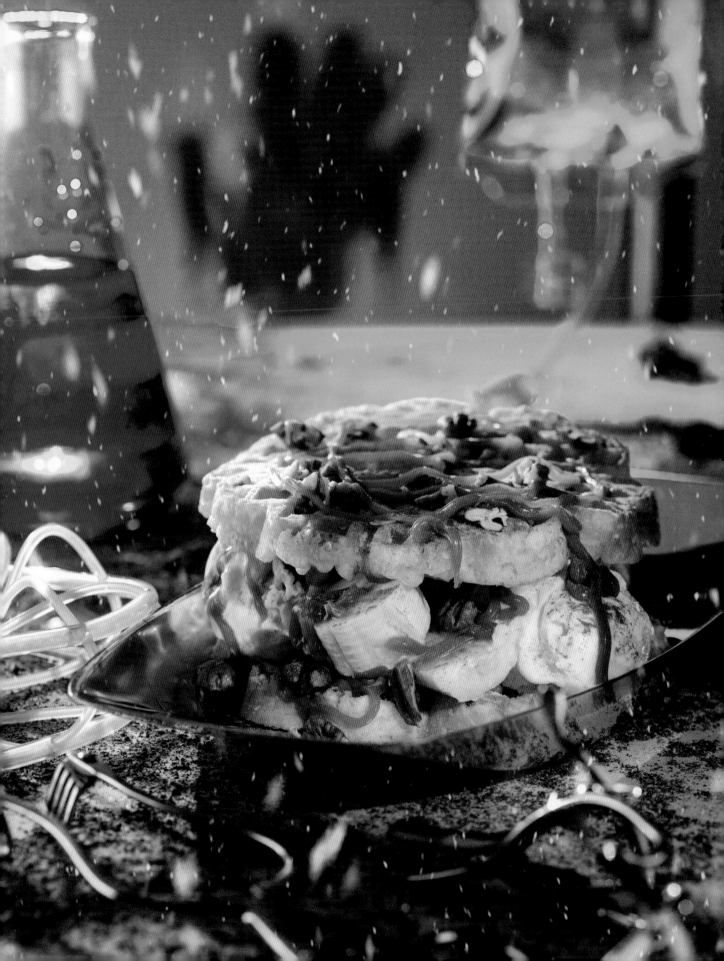

# Bananas Foster
# WAFFLES

Eleven and Hopper love to create new kinds of waffle extravaganzas. Combine homemade waffles with buttery rum sauce, bananas, and sweet vanilla ice cream for a decadent dessert.

## INGREDIENTS

MAKES 4

For the waffle batter

* ★ 3 medium eggs
* ★ Salt
* ★ 1 stick plus 1 tbsp/½ cup plus 1 tbsp (4½ oz/125 g) unsalted butter, softened
* ★ ½ cup (3½ oz/100 g) sugar
* ★ 2 cups (8¾ oz/250 g) pastry flour
* ★ ½ tsp baking powder
* ★ 1 tsp ground cinnamon
* ★ Scant 1 cup (7 fl oz/ 200 ml) milk
* ★ Scant ¼ cup (1¾ fl oz/ 50 ml) sparkling mineral water
* ★ Oil, for greasing

For the topping

* ★ Scant ½ cup (3½ oz/ 100 g) whipping cream, chilled
* ★ 2 tsp vanilla sugar
* ★ 4 bananas
* ★ 1 cup (3½ oz/100 g) shelled walnuts
* ★ Caramel sauce (ready-made product)

Extras

* ★ Waffle maker

## METHOD

Separate the eggs, add a pinch of salt, and beat the egg whites with a hand mixer until stiff peaks form.

In a separate bowl, beat the butter with the sugar until thick and fluffy. Incorporate the egg yolks.

In another bowl, mix the flour with the baking powder and cinnamon. Add the creamed butter together with the milk and sparkling water and mix until thoroughly incorporated. Then fold the beaten egg whites into the batter.

Turn on the waffle maker and grease by brushing with oil. Put 2–3 tablespoons of batter per waffle in the middle of the waffle maker and cook until golden brown. Let the finished waffles cool individually on a cake rack. Do not stack them; otherwise they will quickly become greasy!

While the waffles are cooling, whip the cream with the vanilla sugar in a high-sided mixing bowl.

Cut the bananas into thick slices. Coarsely chop the walnuts.

Place a waffle on a plate and add some whipped cream to the center. Spread several banana slices, as desired, over the cream and drizzle liberally with caramel sauce. Sprinkle with walnuts. Cover with a second waffle, leaving flush, top with more caramel sauce and walnuts, and serve immediately.

## STRANGER TIP

Vanilla ice cream makes a particularly good alternative to whipped cream on hot days.

# DRINKS

# CUBA *Libre*

Even from Hawkins, Cuba's sandy beaches are just a stone's throw away. Enjoy a taste of the Caribbean with this simple libation, courtesy of Hawkin's local pub, The Hideaway.

## INGREDIENTS

MAKES 1

* Cane sugar
* 2 tbsp plus 2 tsp (1⅜ fl oz/40 ml) rum
* 4 tsp (¾ fl oz/20 ml) freshly squeezed lemon juice (or lime juice)
* ⅔ cup (5 fl oz/150 ml) cola
* 1 slice lemon (or lime)

Extras

* Ice cubes

## METHOD

Fill a glass with ice cubes.

If desired, sprinkle a little cane sugar over the ice.

Pour the rum and lemon juice over the ice. Then fill the glass with cola and stir well.

Garnish with a slice of lemon and serve immediately.

# *Ahoy*
# SUMMER SLUSHY

Different slushy flavors don't just cause a commotion in Murray's apartment. Whether strawberry, cherry, or blue raspberry, this popular drink calms all temperaments any time of the year.

## INGREDIENTS

MAKES 2

★ 1 lb 2 oz (500 g) ice cubes (about 2 cups prepared)

★ 2 tbsp plus 2 tsp (1⅜ fl oz/40 ml) lime juice (or lemon juice)

★ 2 tbsp plus 2 tsp (1⅜ fl oz/40 ml) Blue Curaçao syrup (nonalcoholic)

★ Scant ½ cup (3½ fl oz/100 ml) lemonade

## METHOD

Finely crush the ice in a food processor. Divide the crushed ice between two tall glasses, filling almost to the top.

In a mixing glass, combine the lime juice with the Blue Curaçao syrup and lemonade. Then pour it into the glasses and stir with a long-handled spoon to evenly distribute.

Serve with a drinking straw.

## STRANGER TIP

If you like your slushy with a kick, substitute Blue Curaçao liqueur for the syrup.

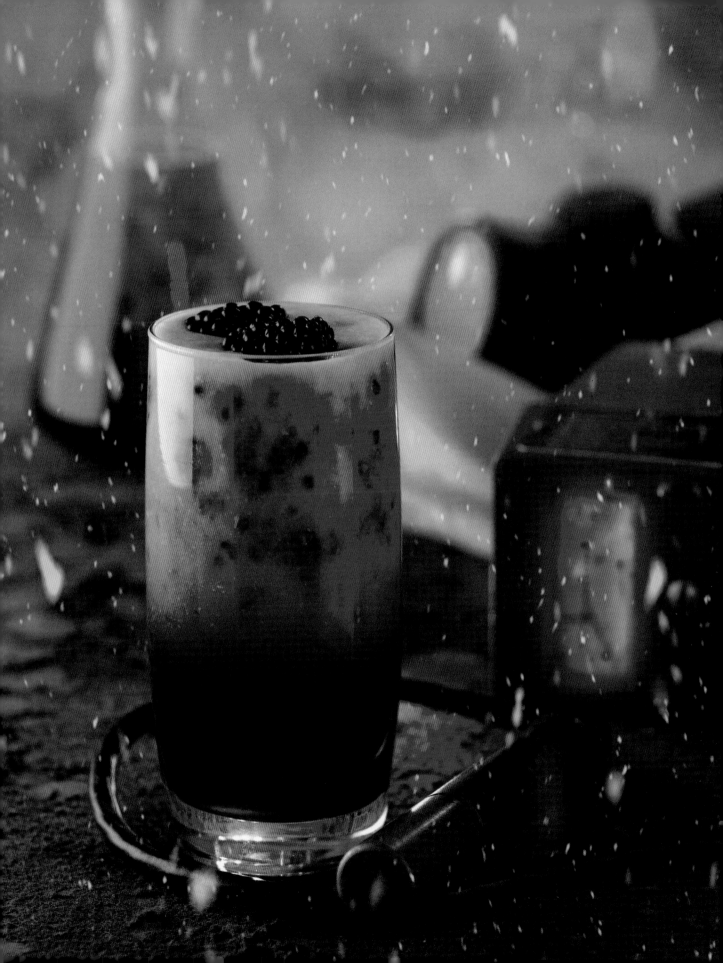

# *The* UPSIDE DOWN

This cocktail is a bit tamer than the Upside Down, but who really wants to drink something like that? This swirling drink is the perfect cocktail for your next Halloween party. Raise a glass to Barb and enjoy the spookiest night of the year.

## INGREDIENTS

MAKES 1

* 6 raspberries and 6 blackberries
* 4 tsp (¾ fl oz/20 ml) cherry syrup
* 1 tbsp (1 oz/30 ml) tequila
* 1 tbsp (1 oz/30 ml) orange liqueur (e.g., Cointreau)
* ⅔ cup (5 fl oz/150 ml) cranberry juice
* 1 tbsp (1 oz/30 ml) lime juice
* 1 tbsp (1 oz/30 ml) lemon juice
* 1 tbsp (1 oz/30 ml) simple syrup

Extras

* Cocktail shaker
* Ice cubes

## METHOD

Set aside one raspberry and one blackberry each as a garnish.

Wash the remaining berries and roughly mash with a fork in a bowl. Add the cherry syrup and gently incorporate.

Fill a cocktail shaker halfway with ice cubes. Add the tequila, orange liqueur, cranberry juice, lime juice, lemon juice, and syrup and shake vigorously for 10–15 seconds.

Pour the mashed berry mixture into a tall cocktail glass. Strain the contents of the shaker over it, discarding the ice. Stir briefly and garnish with the remaining berries. Serve immediately.

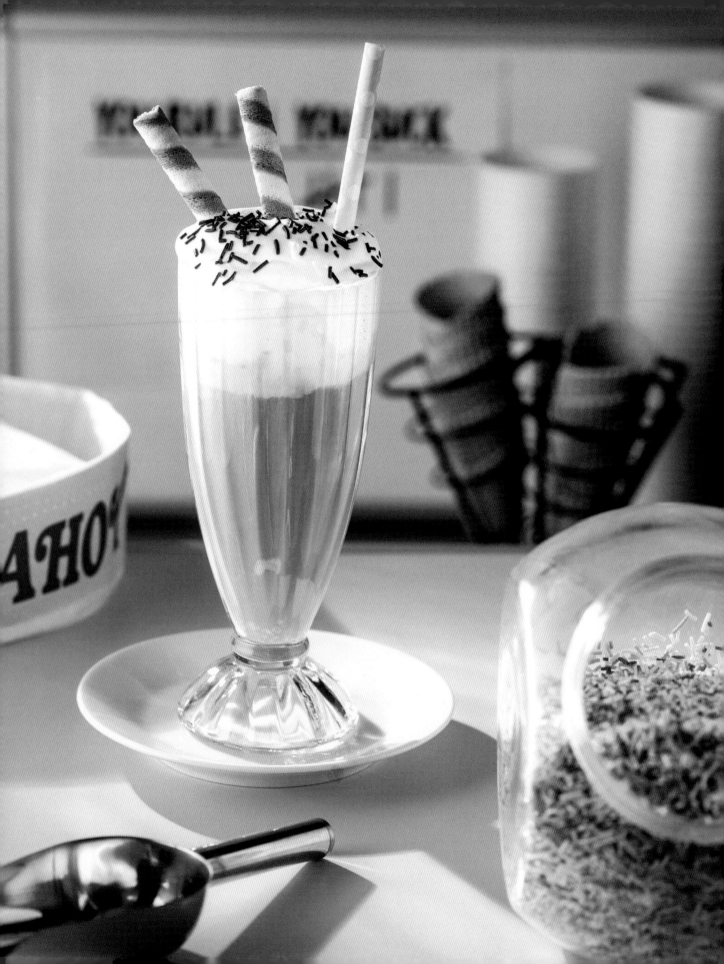

# Ahoy
# ICED COFFEE FLOAT

Imagine yourself sitting in Scoops Ahoy during summertime with this decadent iced coffee. This caffeinated twist on the classic root beer float will make any coffee lover's heart race, even when summer seems far away.

## INGREDIENTS

MAKES 1

★ Scant 1 cup (7 fl oz/ 200 ml) brewed coffee

★ Sugar (as needed)

★ Scant ¼ cup (1¾ oz/50 g) whipping cream

★ 2 scoops vanilla ice cream

★ Chocolate sprinkles, for decoration

★ 2 rolled wafers, for decoration

## METHOD

Brew the coffee and sweeten with sugar to taste while still hot. Let cool and then chill in the refrigerator

In the meantime, whip the cream until stiff peaks form.

Put two scoops of vanilla ice cream into a tall glass and pour over the cold coffee. Top with the whipped cream. Decorate with chocolate sprinkles and the two wafer rolls and enjoy immediately!

# Benny's Burgers
# ICED TEA

Summertime is also iced tea time! When temperatures are high, this mix of chilled black tea, homemade syrup, and fresh peaches is just what you need.

## INGREDIENTS

SERVES 4

- ★ 5 peaches
- ★ 4 tbsp sugar
- ★ 4 black tea bags
- ★ 1 tbsp lemon juice
- ★ Ice cubes

Extras

- ★ 1½-quart (1.5-L) or larger pitcher

## METHOD

Peel, pit, and cut the peaches into wedges.

In a saucepan over medium heat, bring the sugar and generous 1 cup (8¾ fl oz/250 ml) water to a boil. Simmer, about 10 minutes, while stirring constantly until the sugar is completely dissolved. Pour through a fine-mesh strainer into a large bowl and let cool.

In the meantime, bring generous 2 cups (17 fl oz/500 ml) of water to a boil, pour over the black tea bags, and add the lemon juice. Steep for 3–4 minutes, depending on how strong or bitter you want the tea. Then remove the tea bags and let cool.

Fill a large pitcher with ice cubes and peach wedges. Add the cold tea and syrup, and fill with generous 2 cups (17 fl oz/500 ml) cold water. Best served chilled.

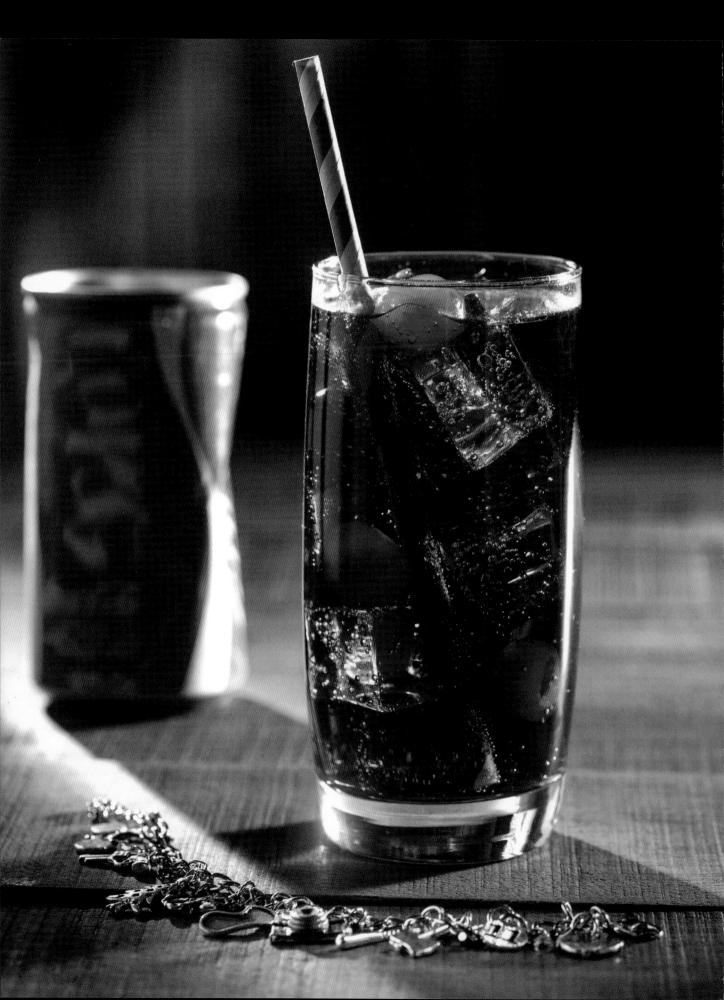

# Eleven's
# MOCKTAIL

This sophisticated mocktail proves that you don't need exotic ingredients or bartending expertise to make great drinks. And the best thing about this nonalcoholic beverage is that it's suitable for young and old!

## INGREDIENTS

MAKES 1

★ 1–2 tbsp (½–1 fl oz/15–30 ml) grenadine (as needed)

★ ¾ cup (6 fl oz/180 ml) cola

★ 4–5 maraschino cherries

Extras

★ Ice cubes

## METHOD

Put the ice cubes into a highball glass.

Pour the grenadine over the ice. The more syrup you add, the sweeter the drink.

Then fill the glass with the cola and garnish with maraschino cherries. Stir well.

Serve with a drinking straw and enjoy immediately.

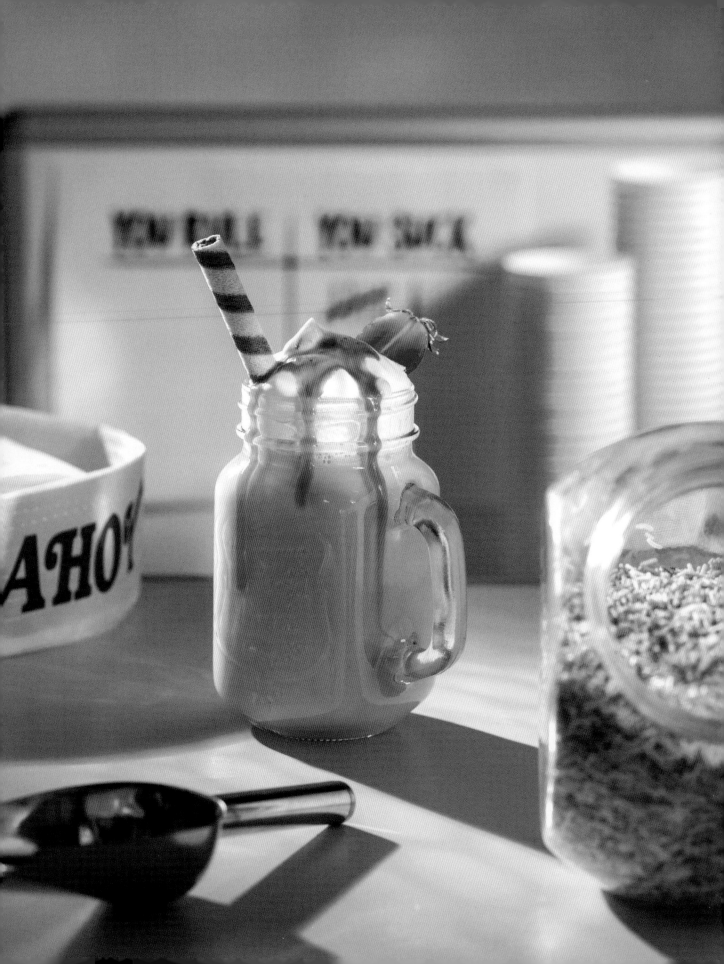

# Classic Strawberry
# MILKSHAKE

Whether as a creamy dessert, fruity energy drink, or a refreshment to enjoy on the go, practically no other drink is so versatile and yet so delicious as a classic milkshake. Feel free to substitute the strawberries with another fruit and the milk and ice cream with your favorite non-dairy choices if needed.

## INGREDIENTS

SERVES 4

* 1 lb (450 g) fresh strawberries
* 4 scoops vanilla ice cream
* 1¼ cups (10 fl oz/300 ml) cold milk
* 1 tsp lemon juice
* 1 tsp vanilla extract
* Scant ½ cup (3½ oz/100 g) whipping cream
* 4 wafer rolls
* Strawberry sauce (ready-made, as needed)

## METHOD

Wash and hull the strawberries. Set aside two strawberries for decoration. Roughly chop the rest and combine in a blender with the ice cream, milk, lemon juice, and vanilla extract. Blend well and then divide the mixture evenly into four tall glasses.

Whip the cream with a hand mixer and add a generous serving to each glass.

Cut the remaining two strawberries in half and decorate the milkshakes. Place a wafer roll in each glass and finish with strawberry sauce. Serve immediately.

# NOTES

# ACKNOWLEDGEMENT

First and foremost, I am grateful to Carina Baier of EMF, my editor, who has proven herself to be a relaxed, reliable collaborator in every way. Thank you for your trust!

I would also like to express my sincere appreciation to Dimitrie Harder, my photographer, who captures all the crazy ideas that run through my head in pictures; "Dimi seine Mudda," for kindly letting me use one or another prop; Jo Löffler and Holger "Holle" Wiest, without whom nothing would have turned out the way it has; and the same goes for Roberts "Rob" Urlovskis; Ulrich Peste, "die Peste"; Holger Kappel; Hannah Kwella, Karin Michelberger, and Franz-Christoph Heel; Monika Schlitzer; my "brotha from anotha motha" Thomas Böhm, together with his appendix; Tobias, Andrea, Lea, Finja, and the guy she's been hanging out with for a couple of years, Jannik or Jannis or something; Katharina "the one and only cat" Böhm; Annelies Haubold; the late, incomparable, and never to be forgotten Oskar "Ossi" Böhm, who was called away to the other dimension much too soon; and, of course, my remaining family, who have given me the opportunity to experience adventures like this one time and time again.

You can thank these people for everything you like about this book. But feel free to blame me for all the slip ups, inaccuracies, and excessive enthusiasm.

PO Box 15
Cobb, CA 95426

© 2022 Reel Ink Press.

All rights reserved.

No part of this book may be reproduced in any form without written permission
from the publisher.

ISBN: 978-1-958862-08-7

Cover design, layout, and typesetting: Anna Obermüller
Editing and proofreading: Carina Baier
Translation: John Ripoll for Cillero & de Motta
Coordination: booklab GmbH, Munich

Picture credits:
Cover background: Shutterstock/ © Kseniya Ivashkevich;
Mind Flayer: Shutterstock/ © Art and Roam
Interior, chapter opening page: Shutterstock/ © Kseniya Ivashkevich;
forest background: Shutterstock/ © Tom Tom
Children on bicycles, Demogorgon, string lights, Demogorgon flower,
ash flakes: Anna Obermüller

Photography: Tom Grimm

This edition of "DAS INOFFIZIELLE HAWKINS-KOCHBUCH" was first published in
Germany by Edition Michael Fischer GmbH in 2022. Created by Grinning Cat
Productions.

© Edition Michael Fischer GmbH, 2022
www.emf-verlag.de

The trademark STRANGER THINGS and any other trademarks mentioned in this
book are property of their respective owners and are used here for identification
purposes only. This book is unofficial and unauthorized. It is not authorized,
sponsored, endorsed, or licensed by Netflix Studios, LLC, and/or any other person
or entity associated with STRANGER THINGS and/or any other trademark or
company name mentioned herein.

Manufactured in China

10 9 8 7 6 5 4 3 2 1